PAINT BY STICKER™

workman
• NEW YORK •

Copyright © 2016 by Workman Publishing Co., Inc.

ISBN 978-0-7611-8723-3

Concept: Daniel Nayeri, Colleen AF Venable, Phil Conigliaro, Tae Won Yu, Justin Krasner
Art by Phil Conigliaro
Layout & design by Tae Won Yu
Art direction by Colleen AF Venable
Cover design by Timothy Hall and Colleen AF Venable
Editing by Daniel Nayeri
Production editing by Amanda Hong

Workman books are available at special discounts when purchased in bulk for premiums and sales promotions as well as for fundraising or educational use. Special editions or book excerpts can also be created to specification. For details, contact the Special Sales Director at the address below, or send an email to specialmarkets@workman.com.

Workman Publishing Co., Inc.
225 Varick Street
New York, NY 10014-4381

workman.com

WORKMAN and PAINT BY STICKER are registered trademarks of Workman Publishing Co., Inc.

Printed in China on paper from responsible sources
First printing March 2016
20 19 18 17 16 15

INTRODUCTION

IT'S FAIRLY SIMPLE, ACTUALLY. You could try it even now, in your mind. Imagine a sticker. Nothing fancy. Just a swatch of color in a random shape with three or four sides. You remember stickers. They're simple. They're delightful.

Okay, you're holding the sticker. It has a number by it: **D31**. That's easy to remember. **D31**. You take the sticker to the art page. On the page is a silhouette. Inside the silhouette is a network of delicate lines—as if a spider drew you a picture.

All you have to do is find the shape labeled **D31**. It's over there. While you do it, you might think about your day. You might take a moment to feel your own breath and relax. You place the sticker onto the space. It's as if you filled the space with a perfectly even coat of paint. You brought color to the world. It might have been the shocking orange of a fox's tail or the deep blue shadow of a boat on the water.

It's a giddy feeling. Simple beauty. You could do it again. You could paint the whole image. It'd be yours. Don't worry if the lines are a bit off. They look like the irregular stones in a mosaic. Timeless. Simple.

GO AHEAD. YOU'RE A NATURAL.

TIPS TO GET YOU STARTED:

1. The sticker sheets are assigned to each art page by the thumbnail images in the top corners of the sticker sheets.

2. Use the perforations to tear out either the art page or the sticker sheets so you don't have to flip back and forth in the book.

3. Go in any order you like. You're the boss.

4. Place one corner of the sticker down and adjust from there. Be careful, these stickers are not removable.

5. For precision placement, use a toothpick or tweezers.

6. After you complete an image, place a sheet of paper over it and press down with a flat surface, like a ruler or bone folder.

CONTENTS

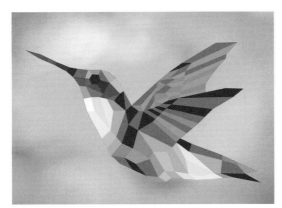

1.

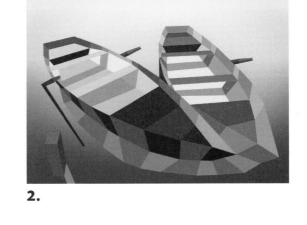

2.

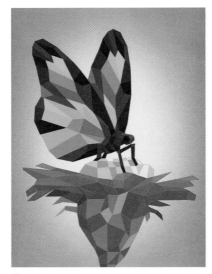

5.

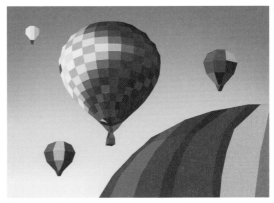

6.

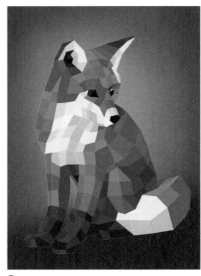

9.

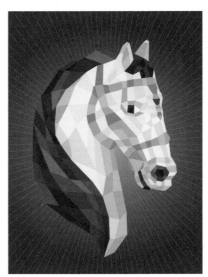

10.

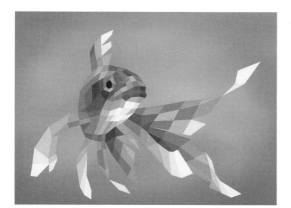

3.

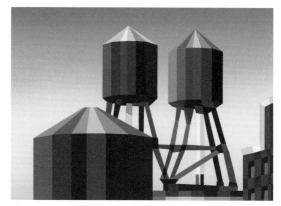

4.

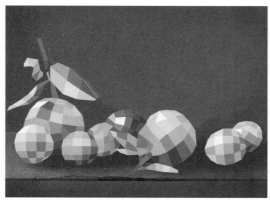

7.

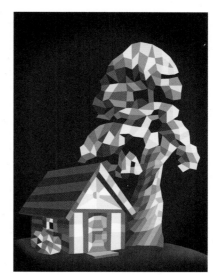

8.

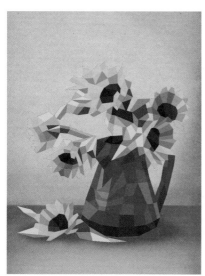

11.

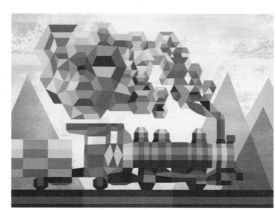

12.

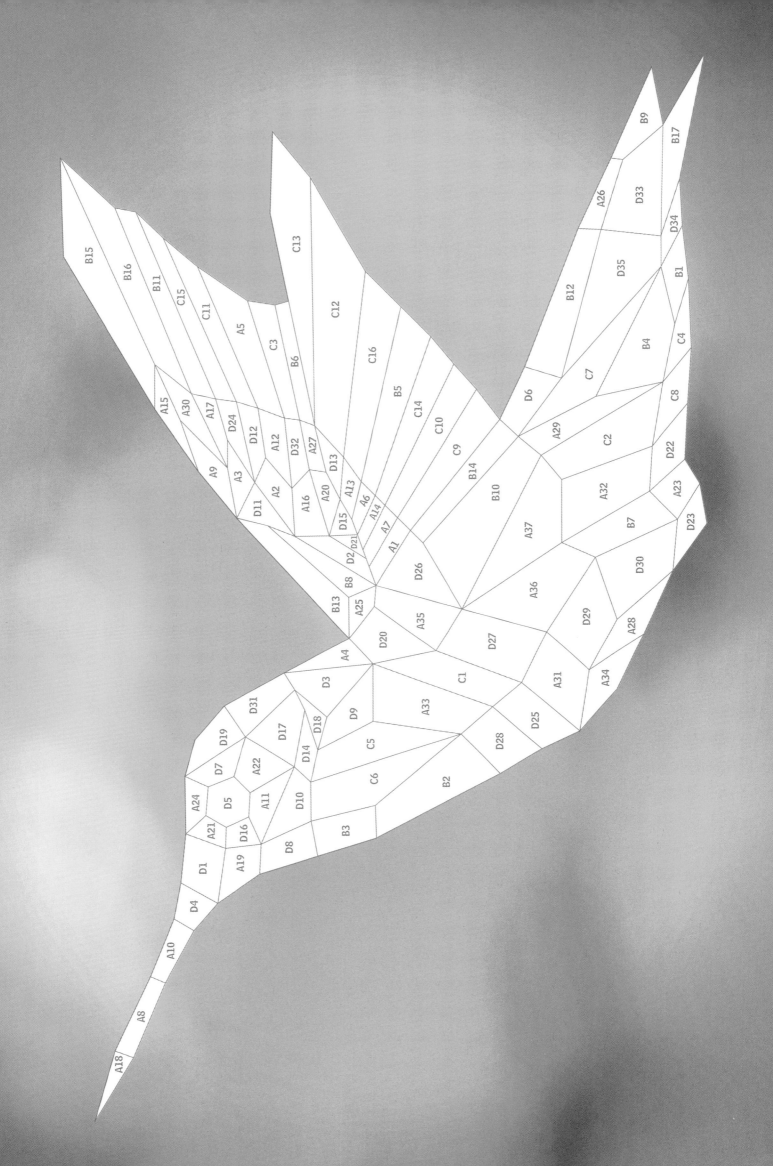

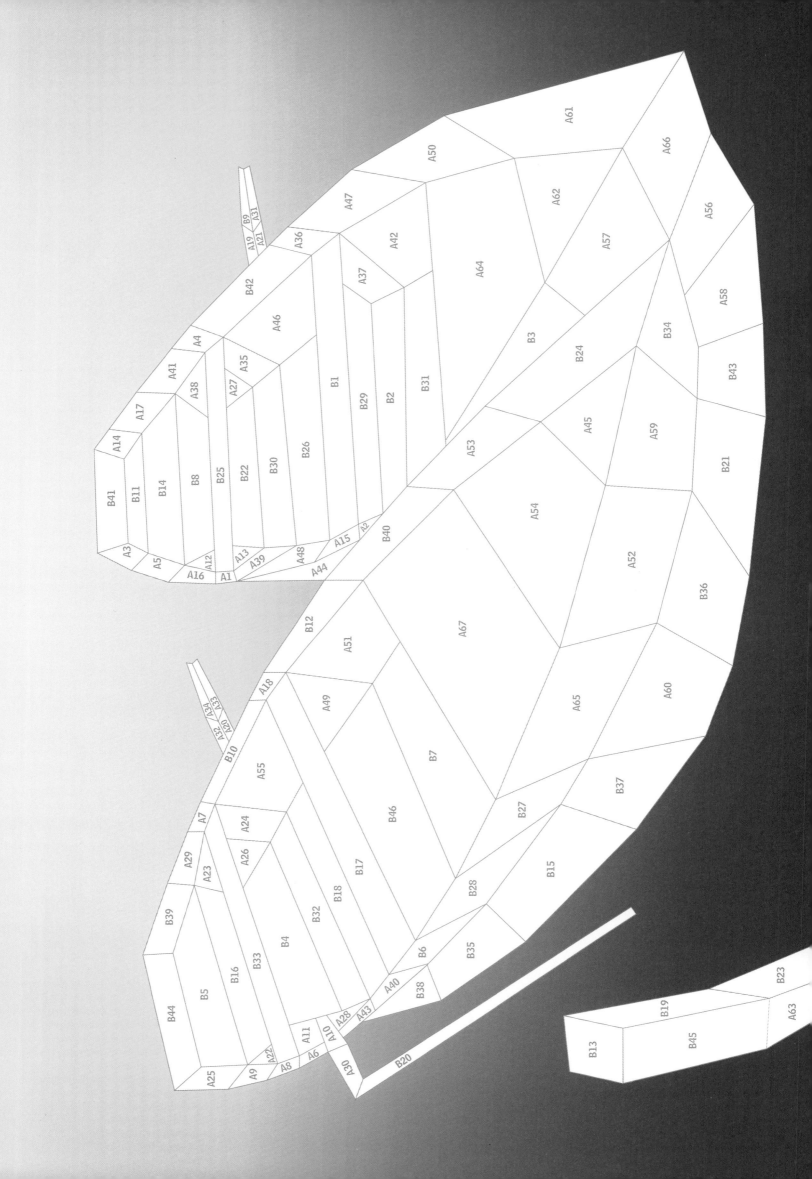

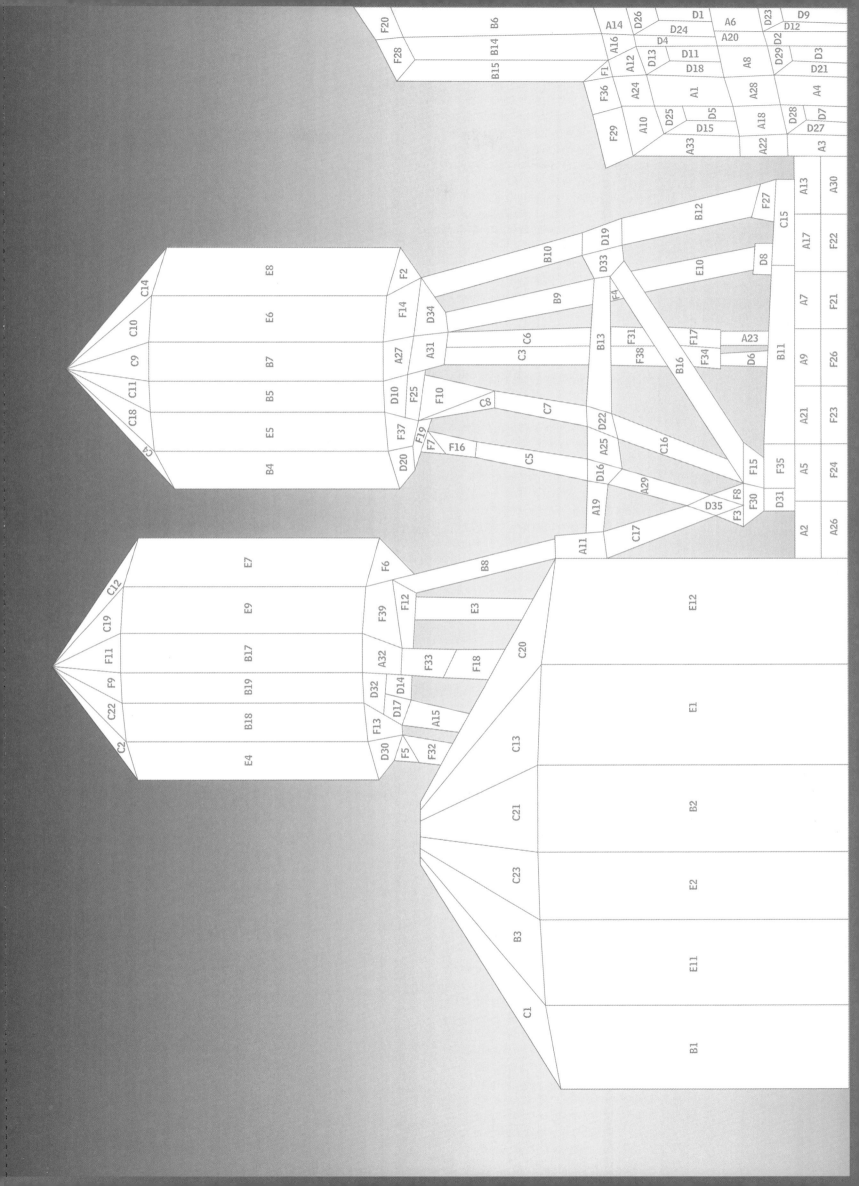

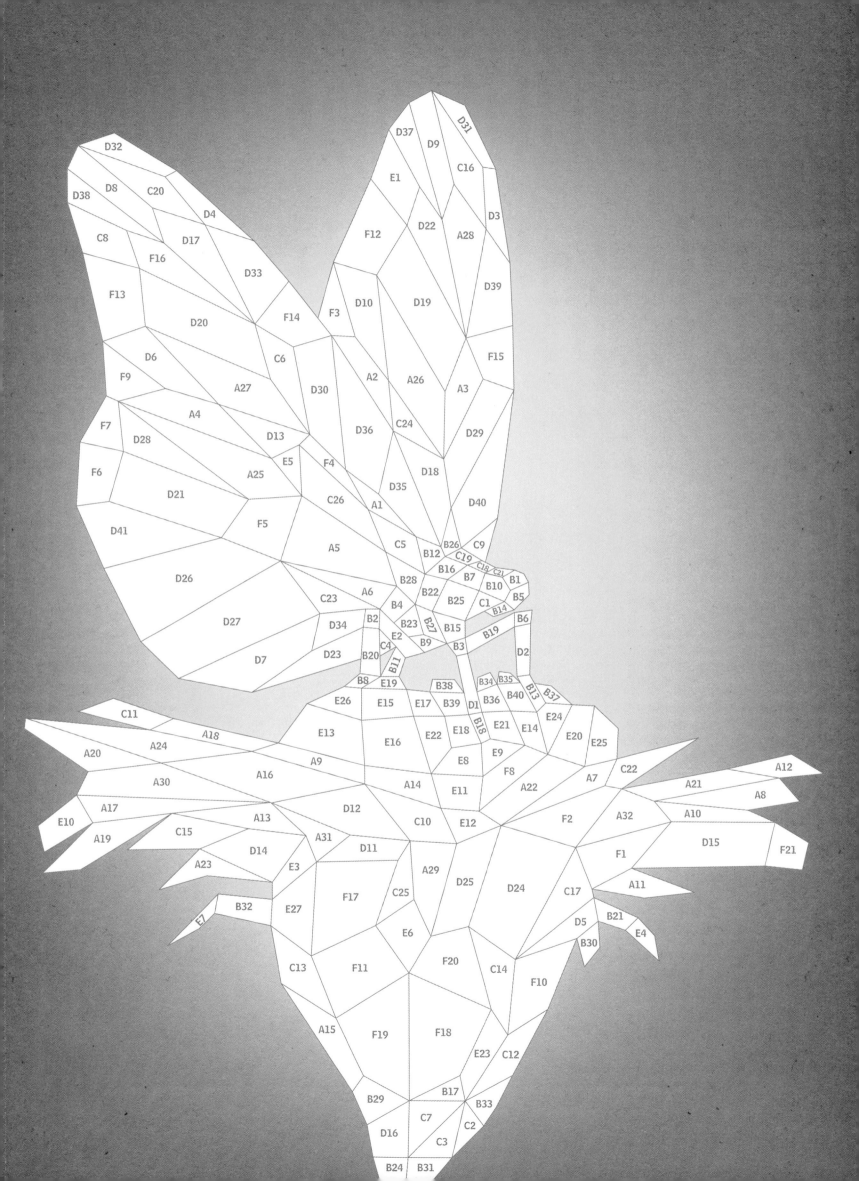

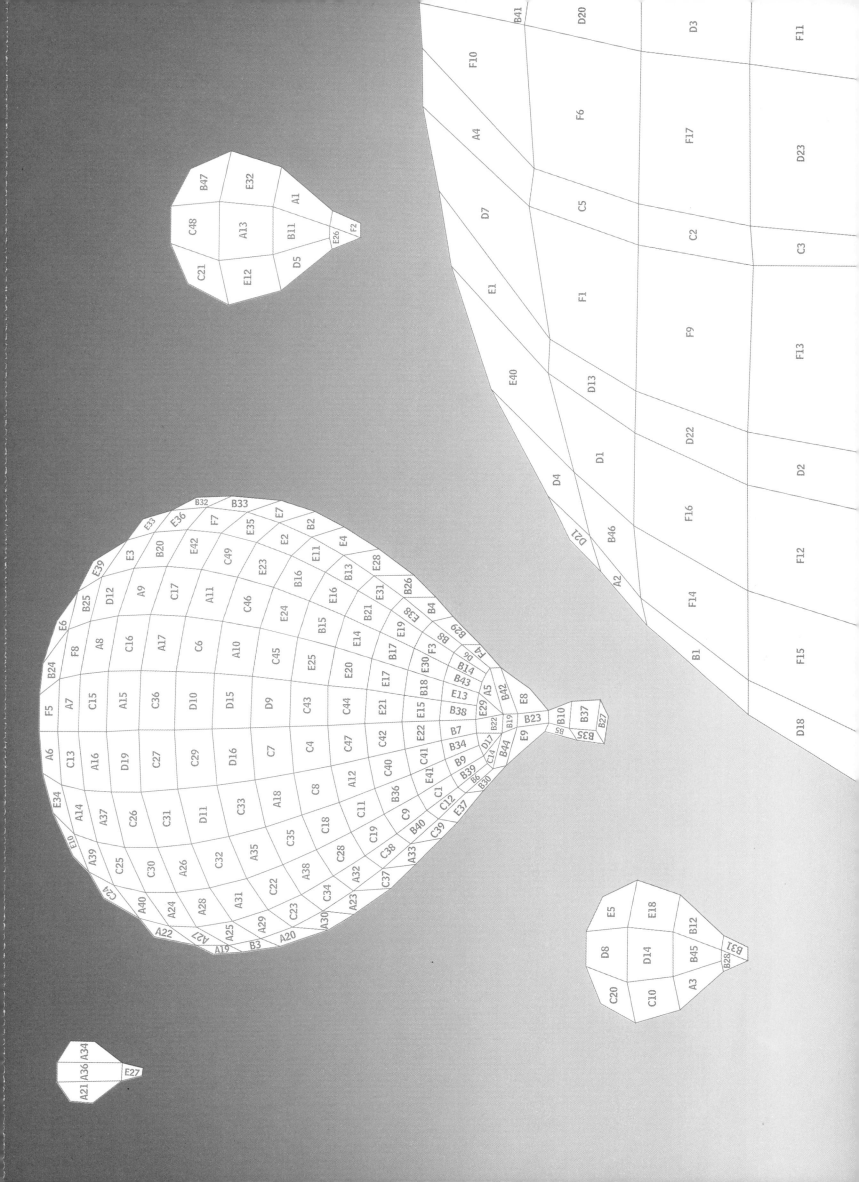

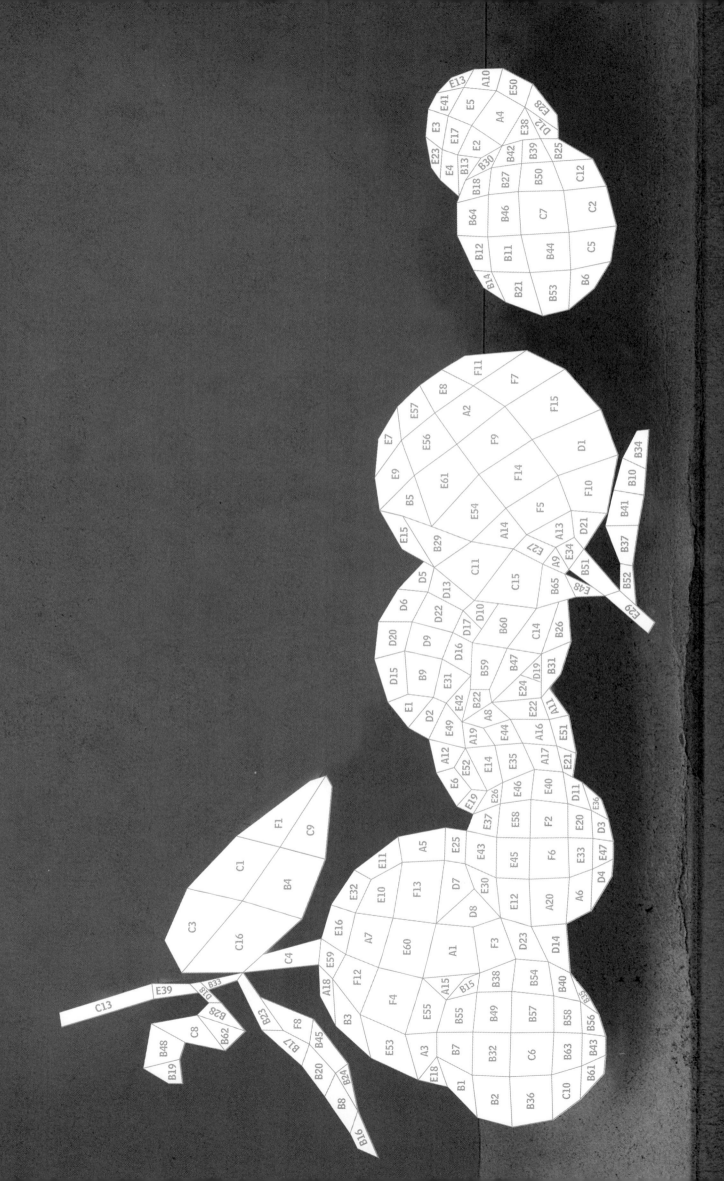

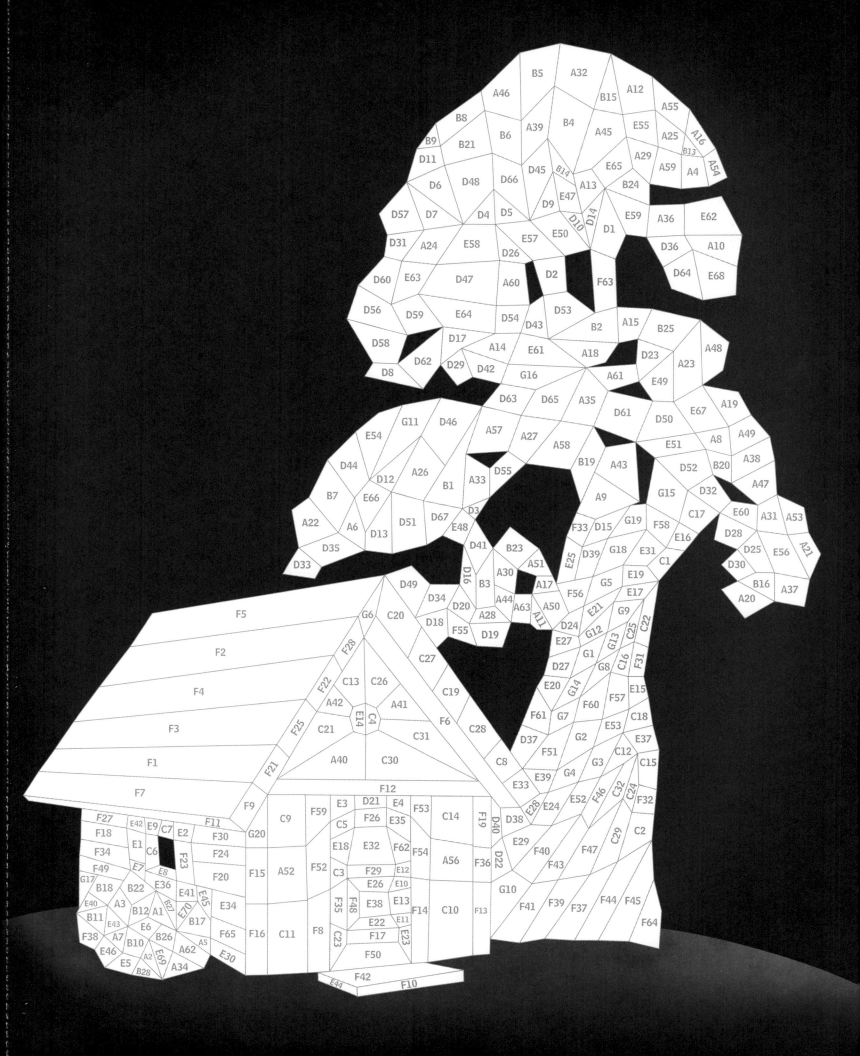

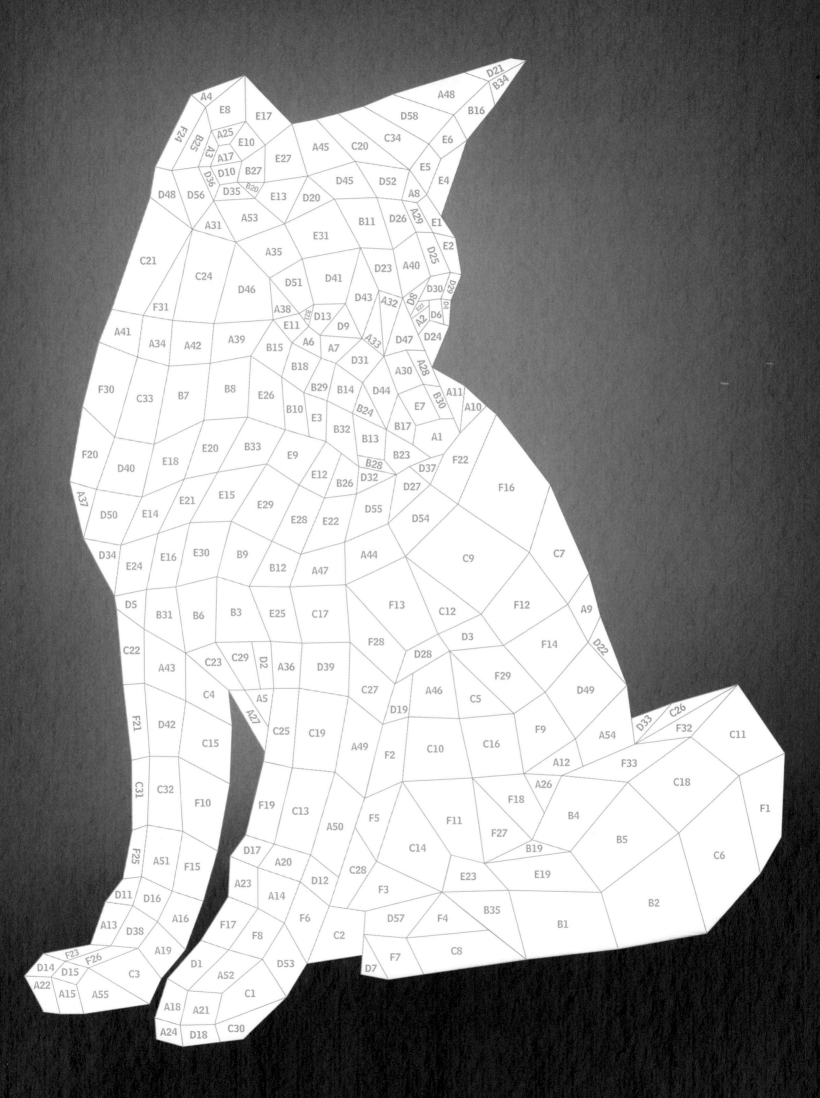

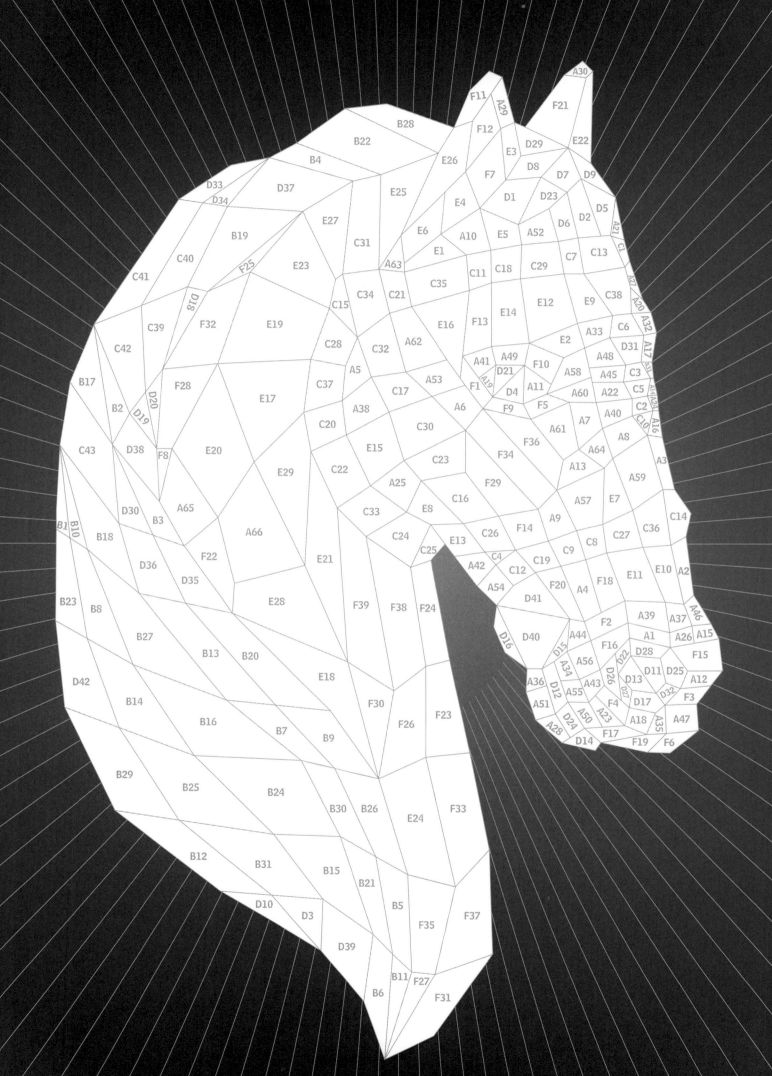

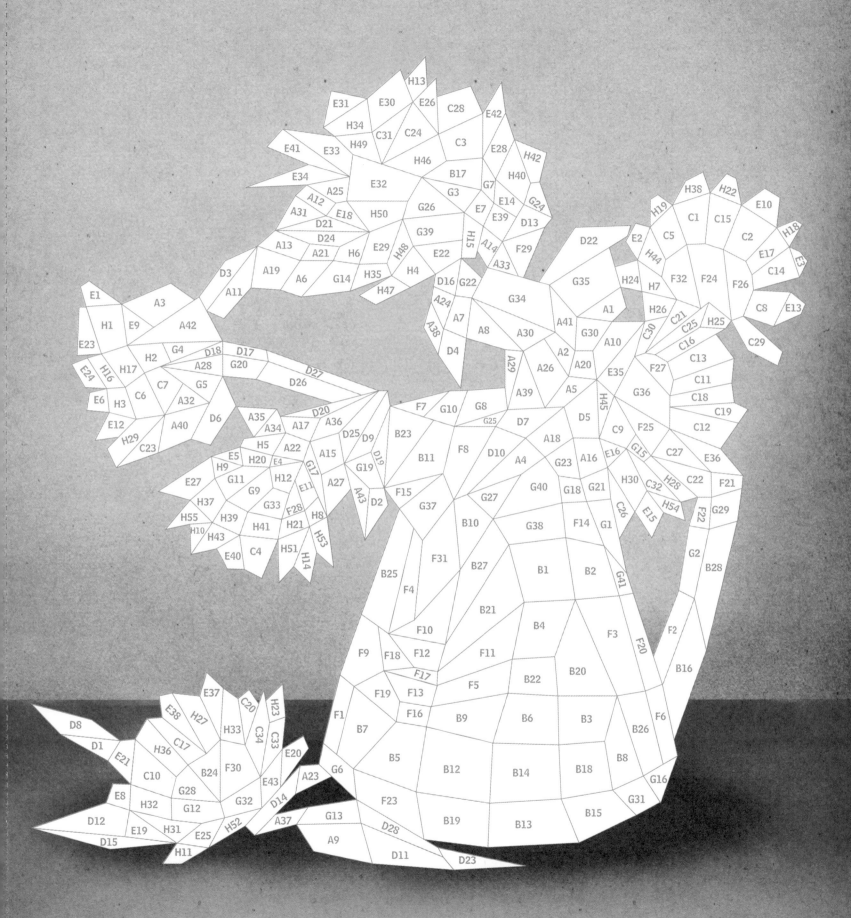

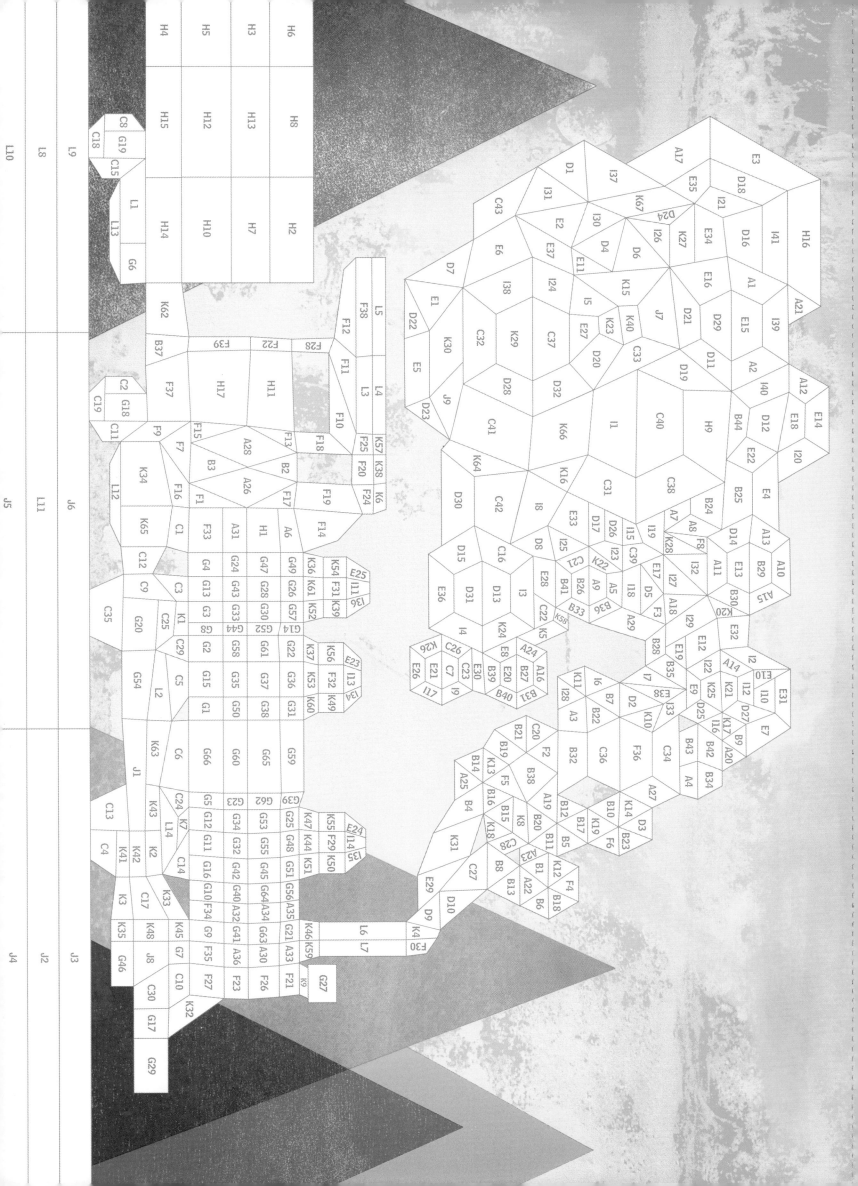

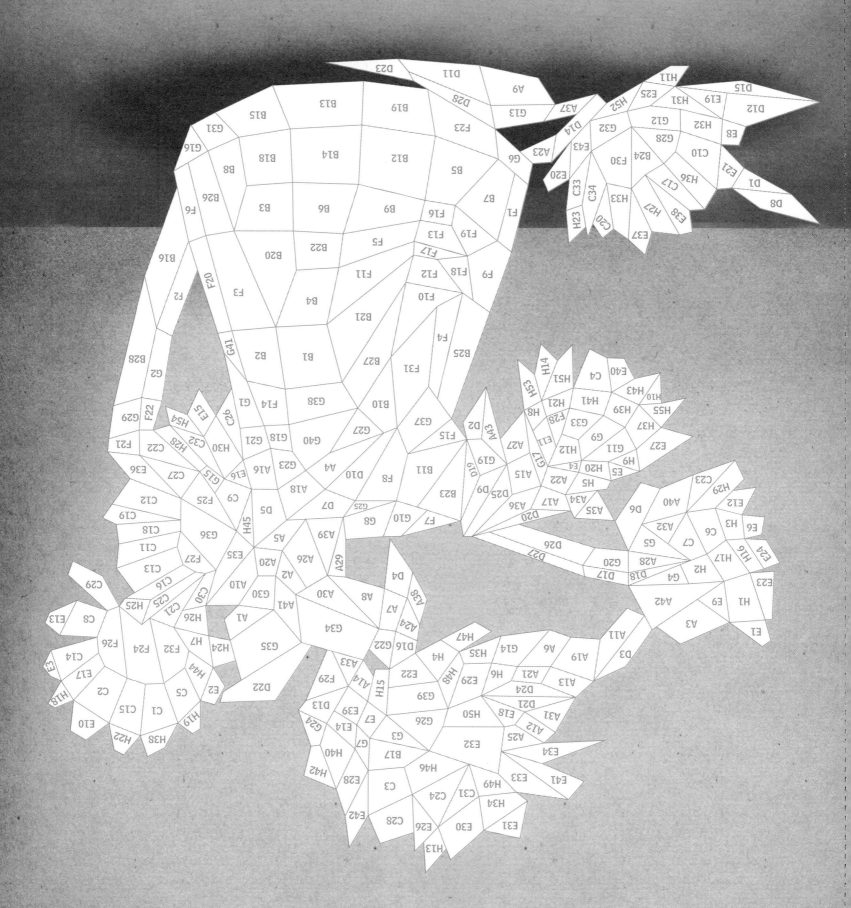

STICKERS

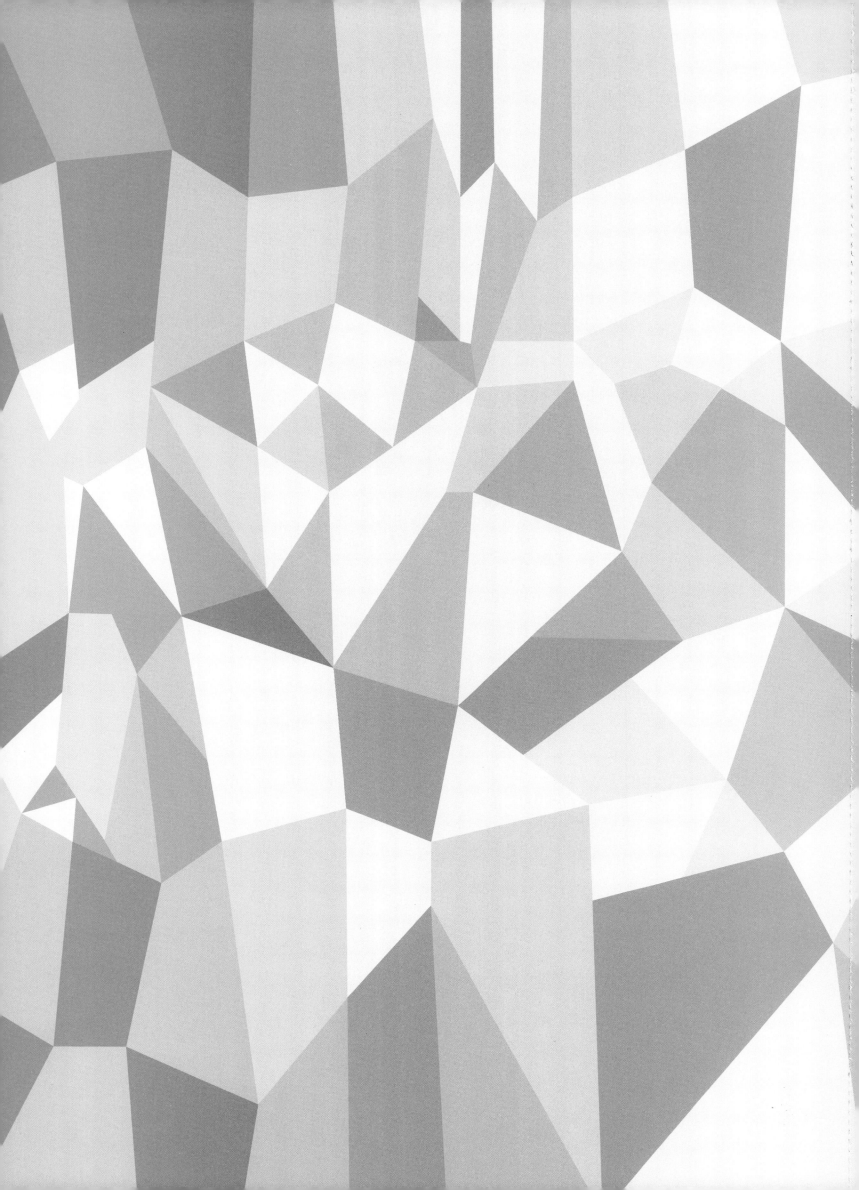

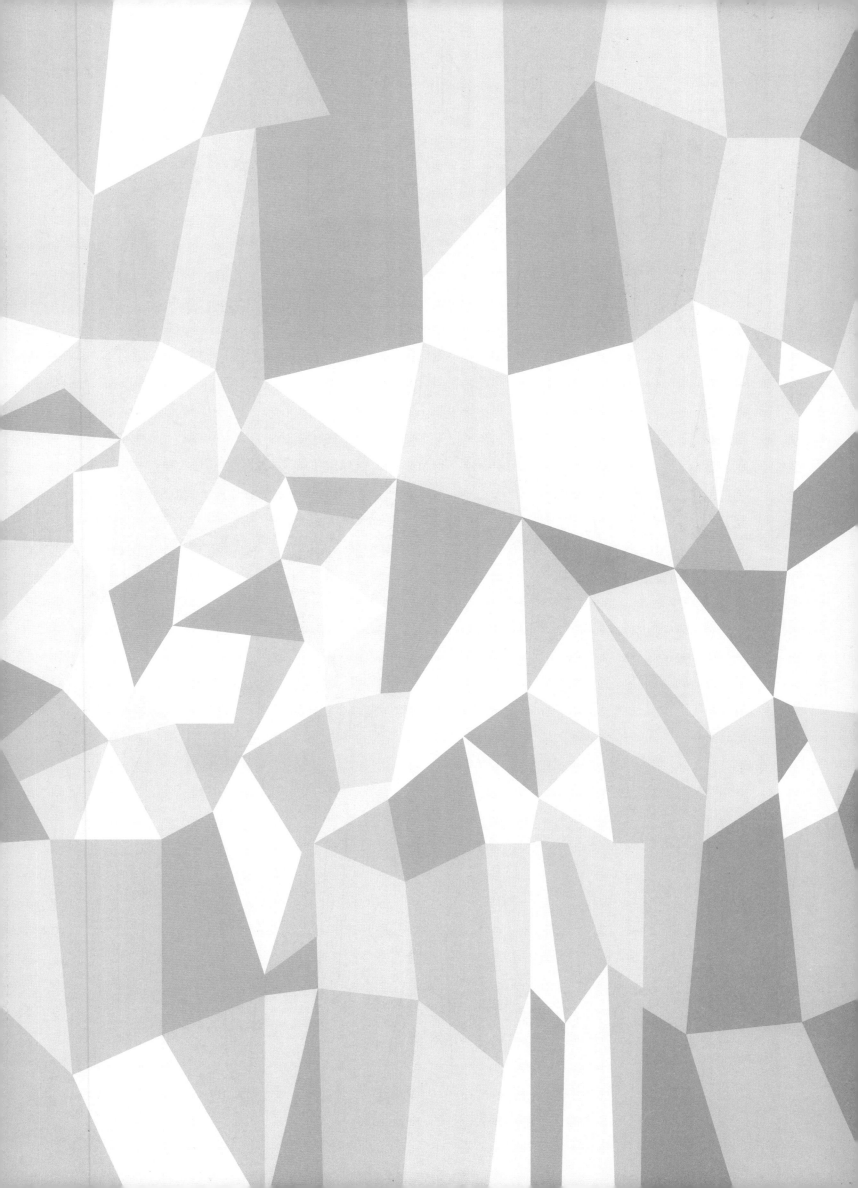

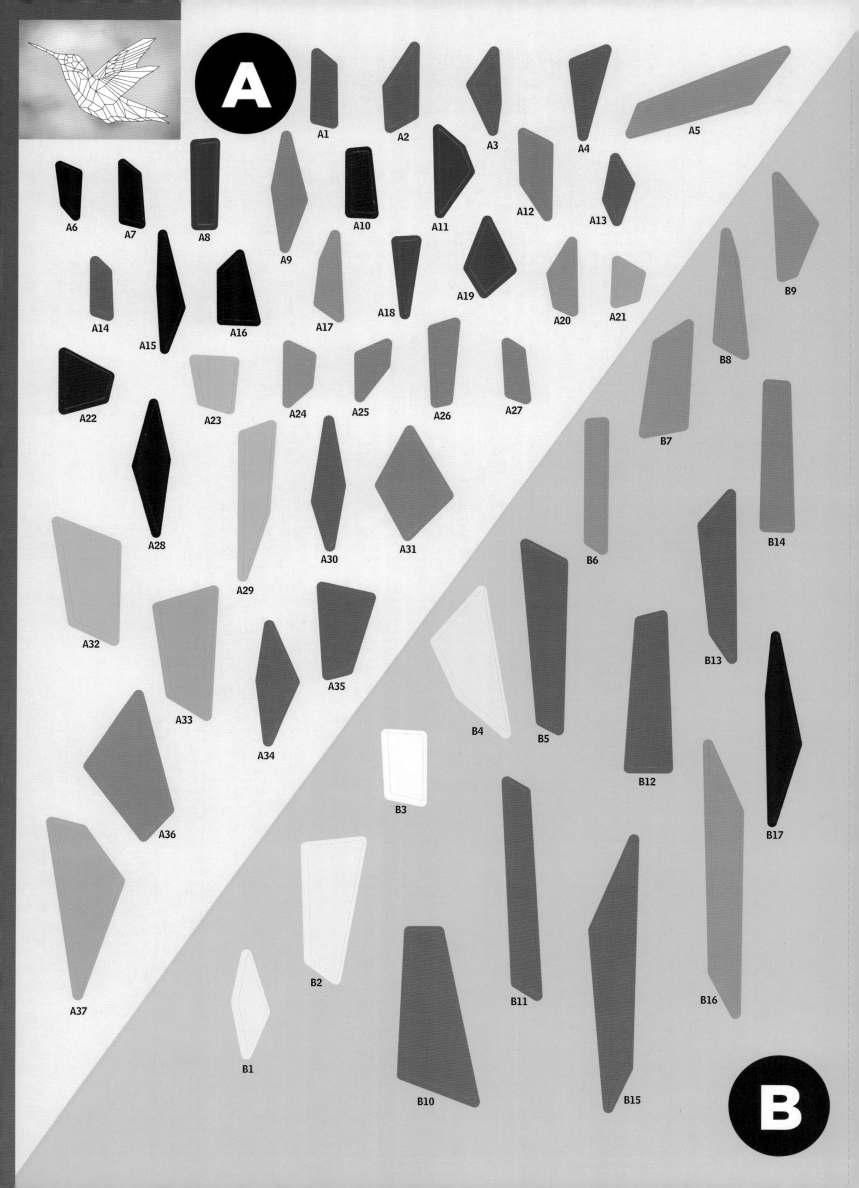

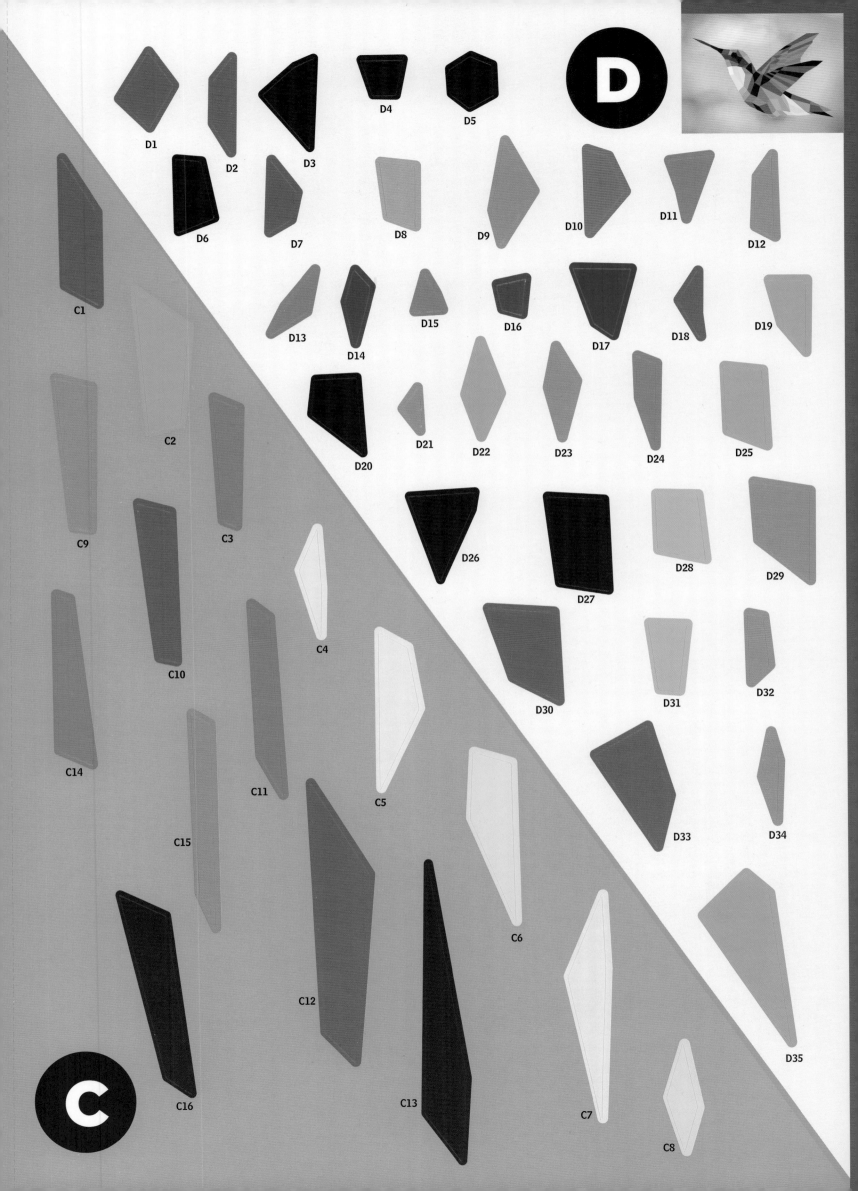

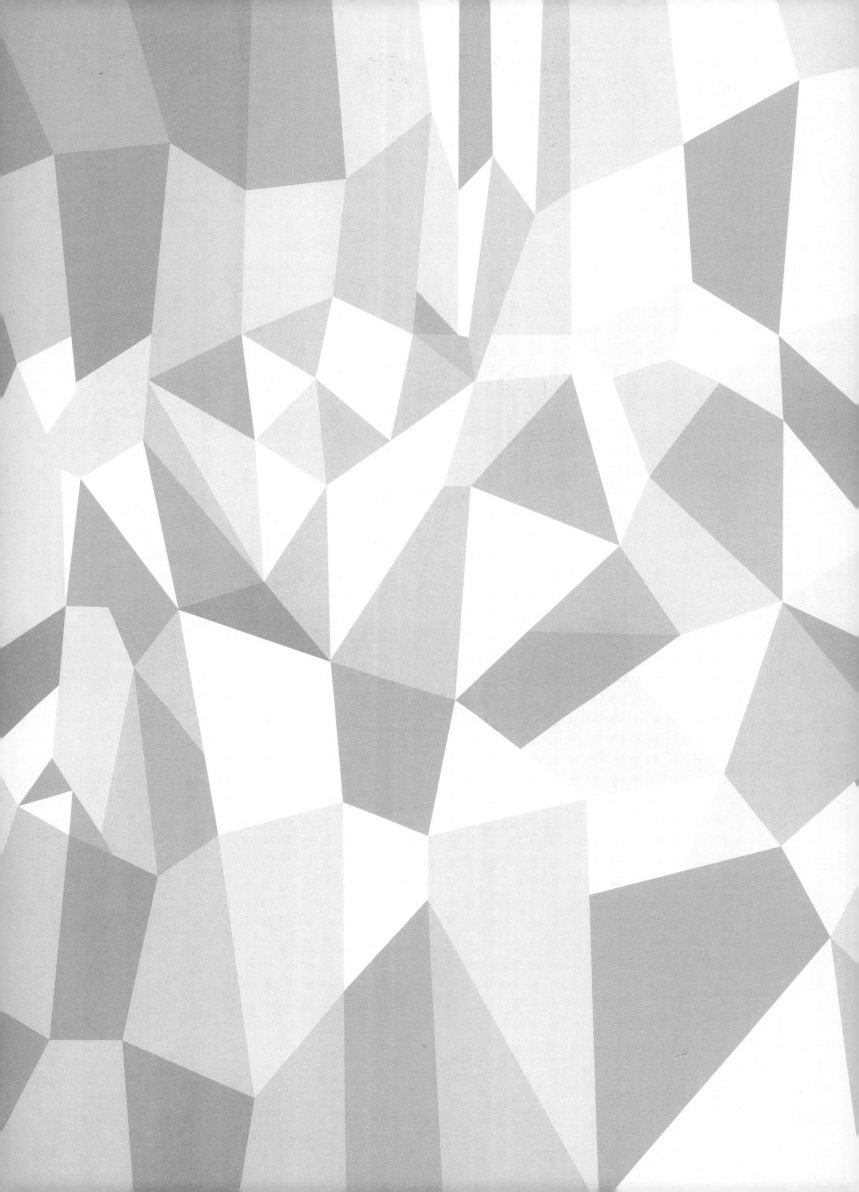

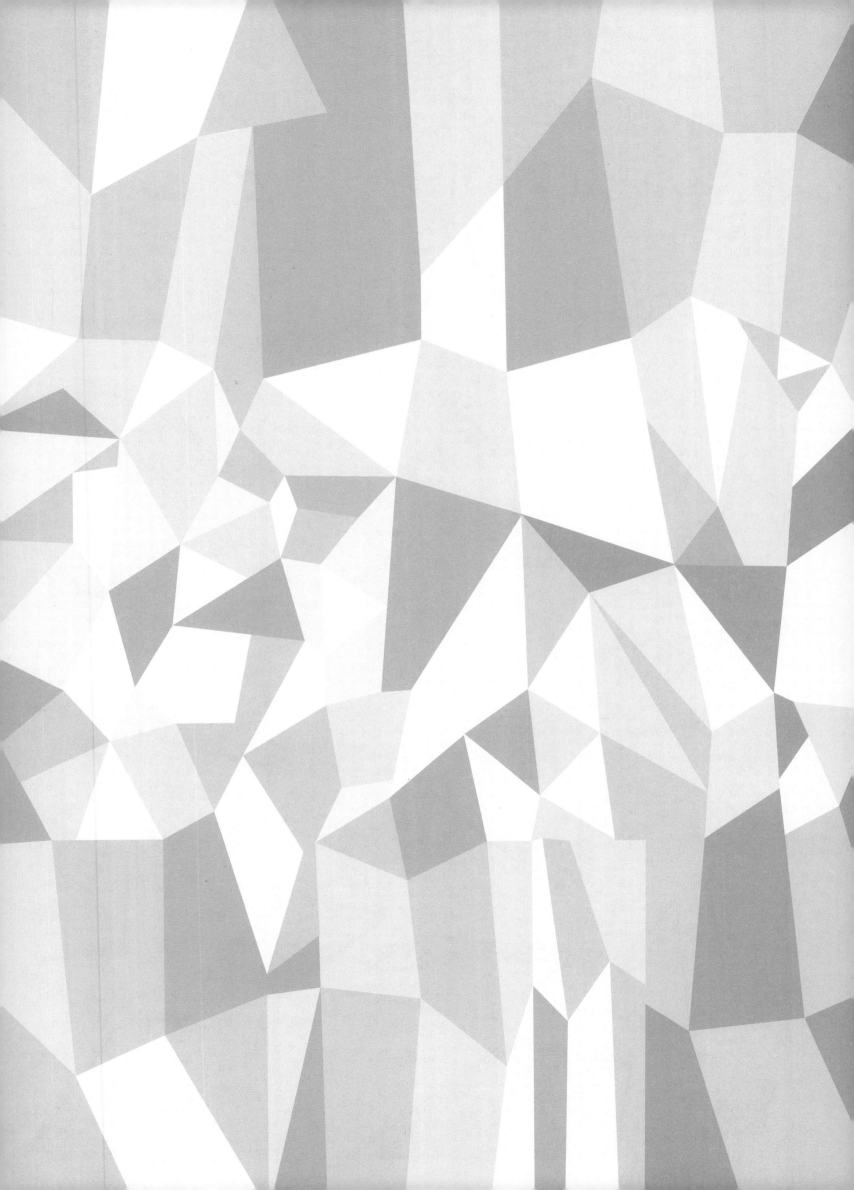

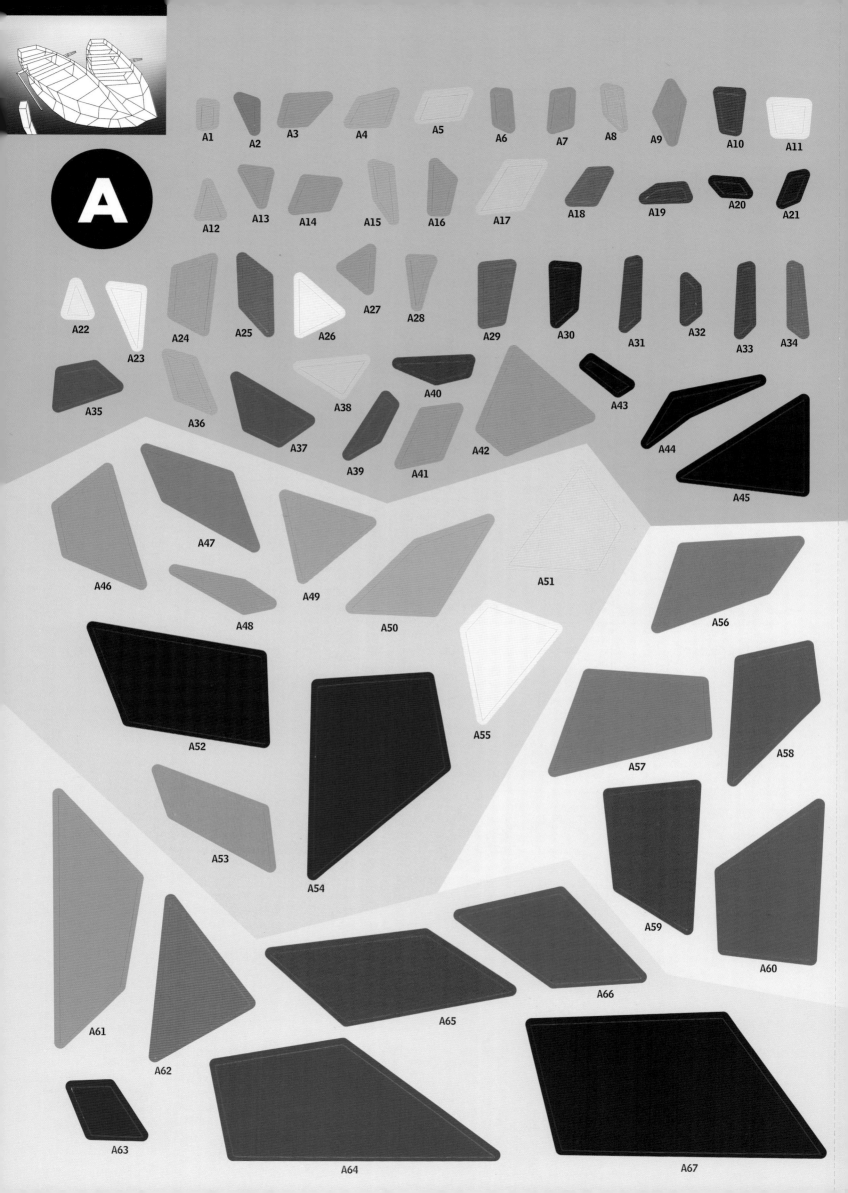

A

A1 A2 A3 A4 A5 A6 A7 A8 A9 A10 A11

A12 A13 A14 A15 A16 A17 A18 A19 A20 A21

A22 A23 A24 A25 A26 A27 A28 A29 A30 A31 A32 A33 A34

A35 A36 A37 A38 A39 A40 A41 A42 A43 A44 A45

A46 A47 A48 A49 A50 A51 A55 A56

A52 A53 A54 A57 A58 A59 A60

A61 A62 A63 A64 A65 A66 A67

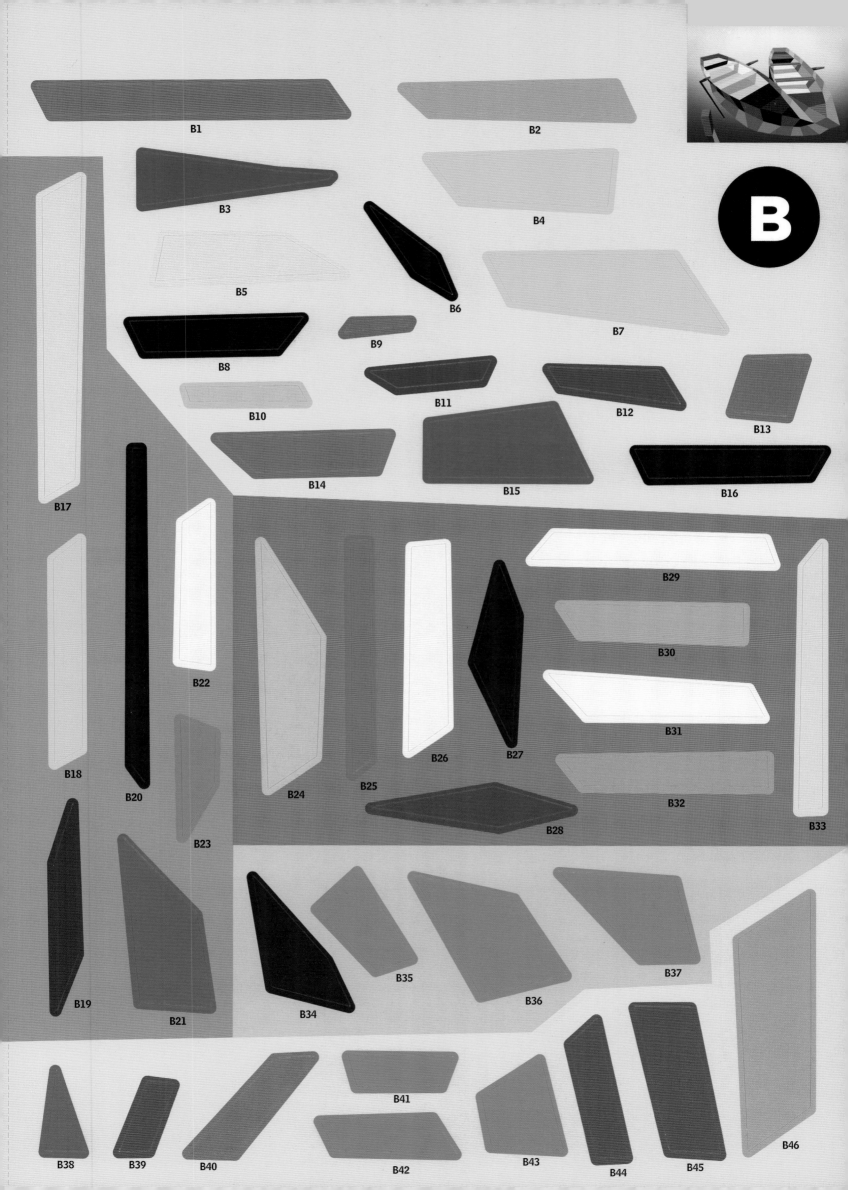

B1

B2

B3

B4

B5

B6

B7

B8

B9

B10

B11

B12

B13

B14

B15

B16

B17

B18

B19

B20

B21

B22

B23

B24

B25

B26

B27

B28

B29

B30

B31

B32

B33

B34

B35

B36

B37

B38

B39

B40

B41

B42

B43

B44

B45

B46

B

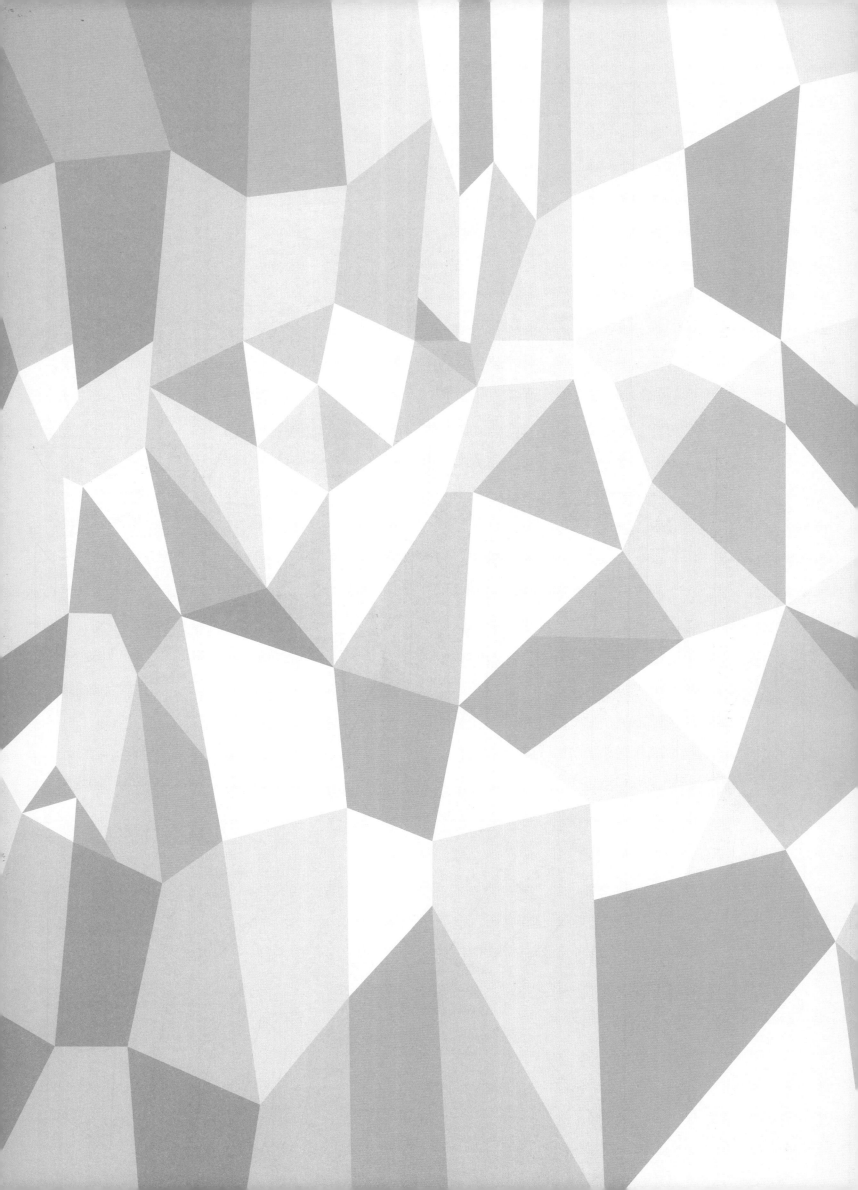

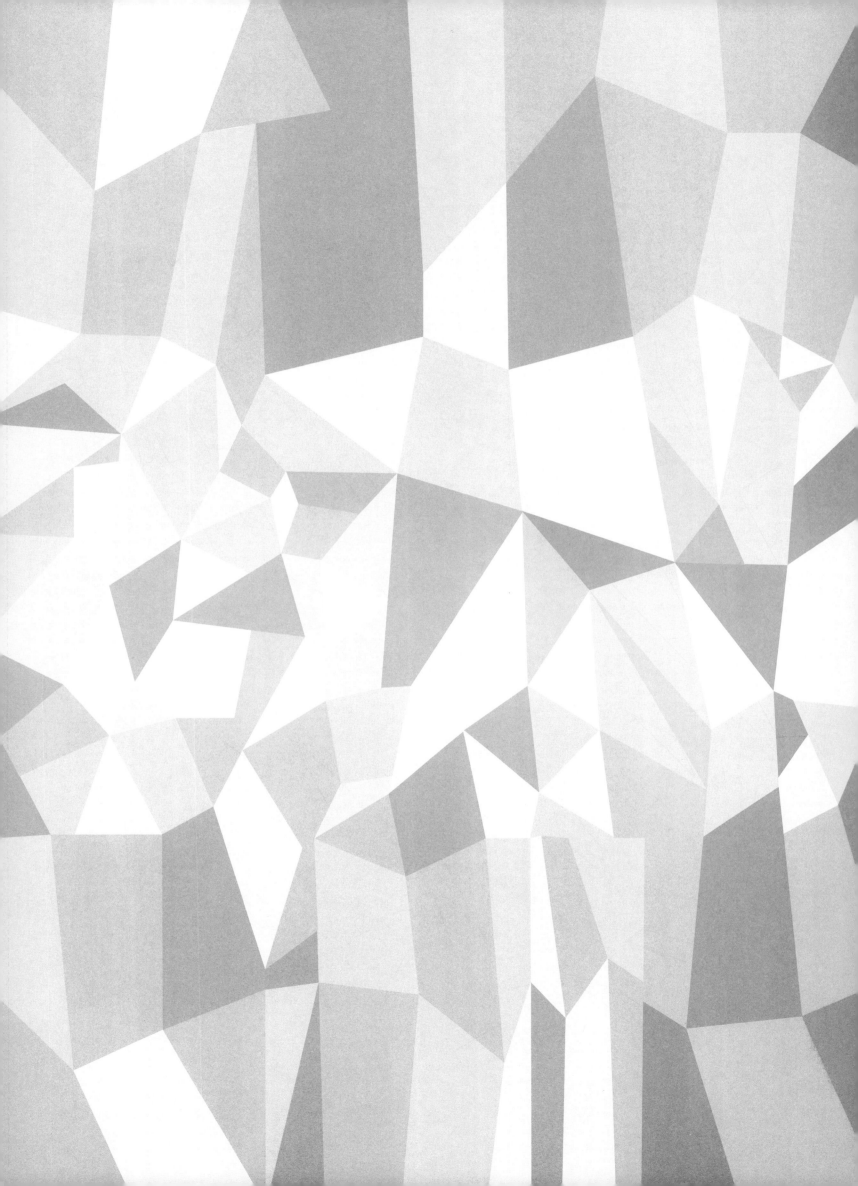

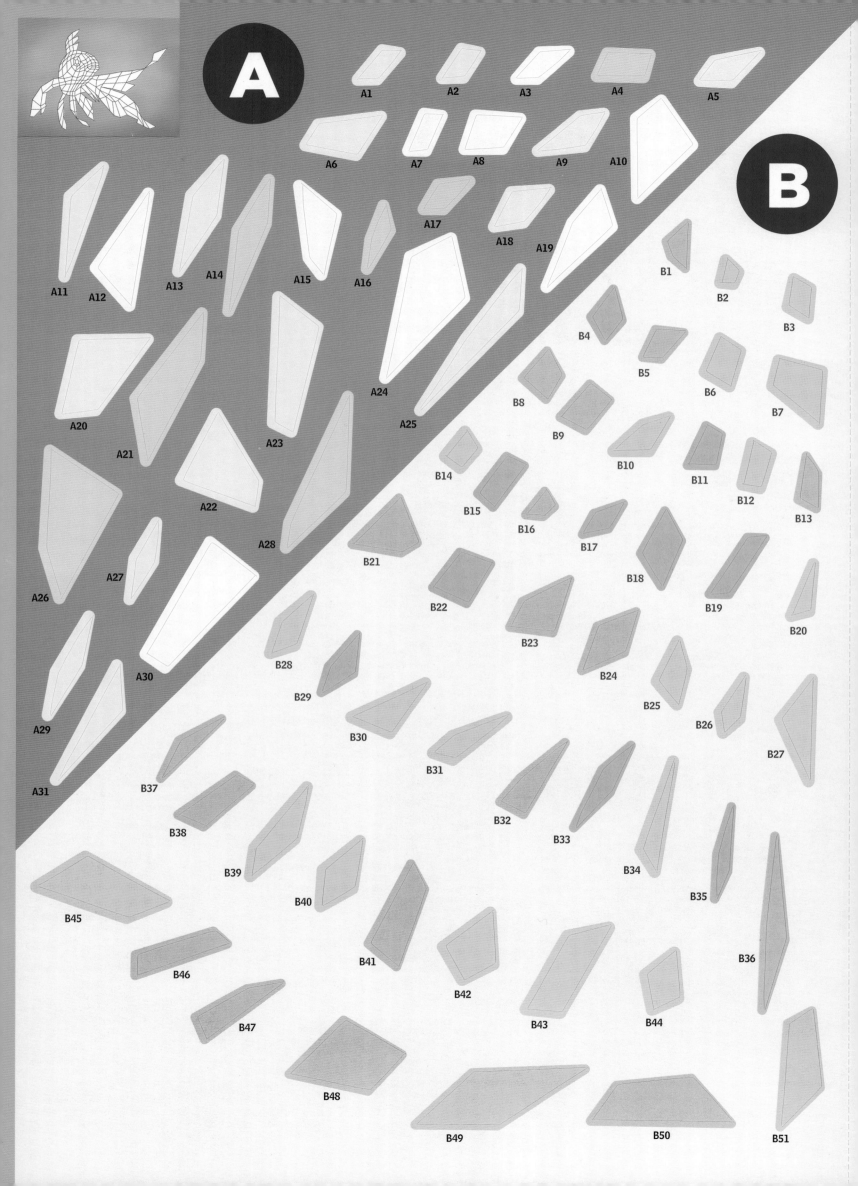

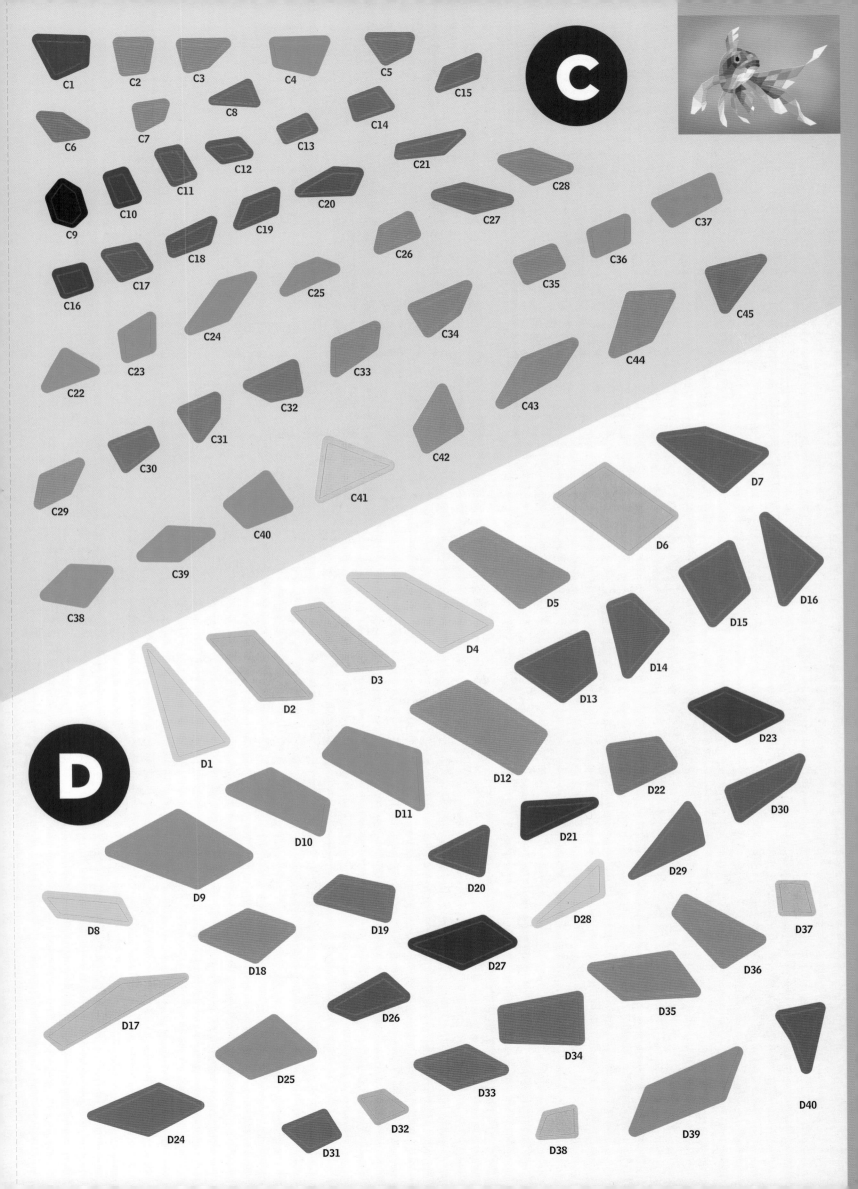

C1 C2 C3 C4 C5 C15

C

C6 C7 C8 C14 C13 C21 C28

C9 C10 C11 C12 C20 C27 C37

C16 C17 C18 C19 C26 C35 C36 C45

C22 C23 C24 C25 C33 C34 C44

C29 C30 C31 C32 C43

C38 C39 C40 C41 C42

D7

D6

D5

D16

D4

D15

D3

D14

D2

D13

D1

D23

D12

D22

D11

D

D21 D30

D10

D20 D29

D9

D28

D8 D19 D37

D18 D27 D36

D17 D26 D35

D25 D34

D24 D33 D40

D32

D31 D38 D39

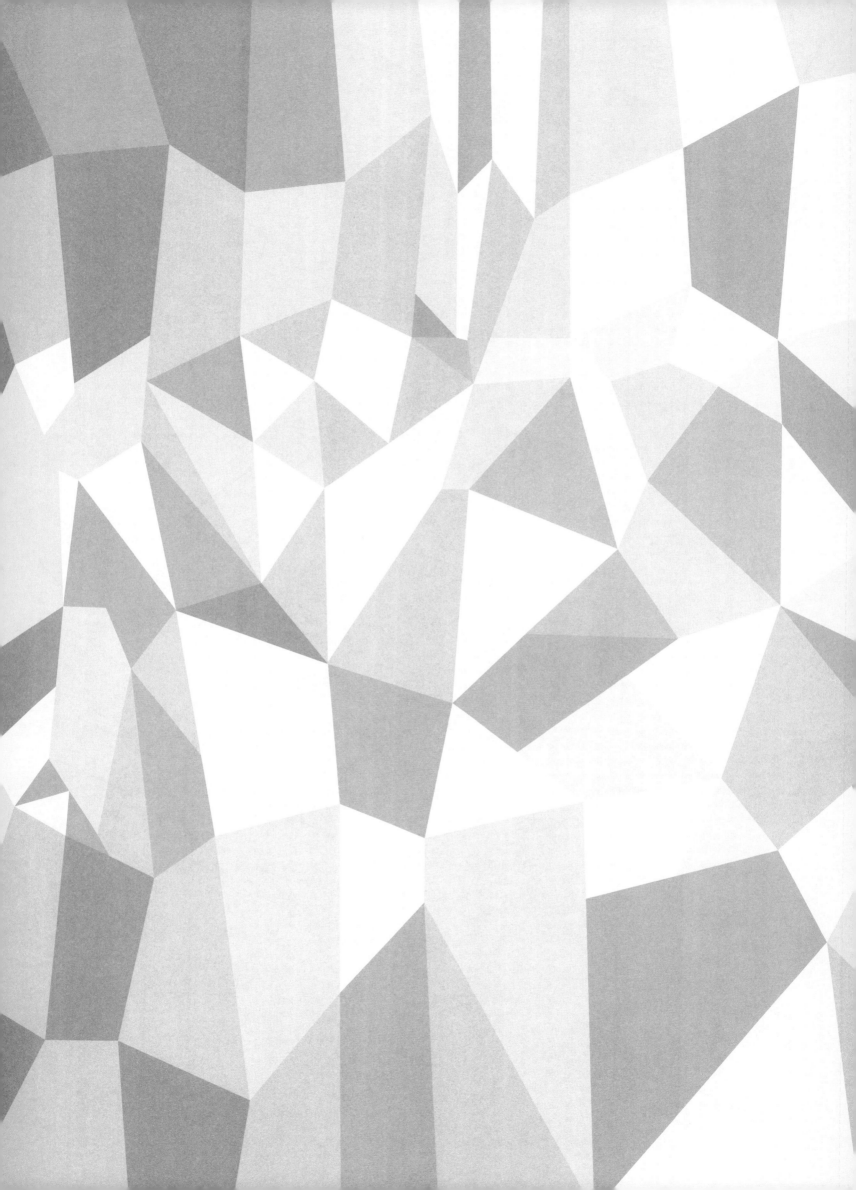

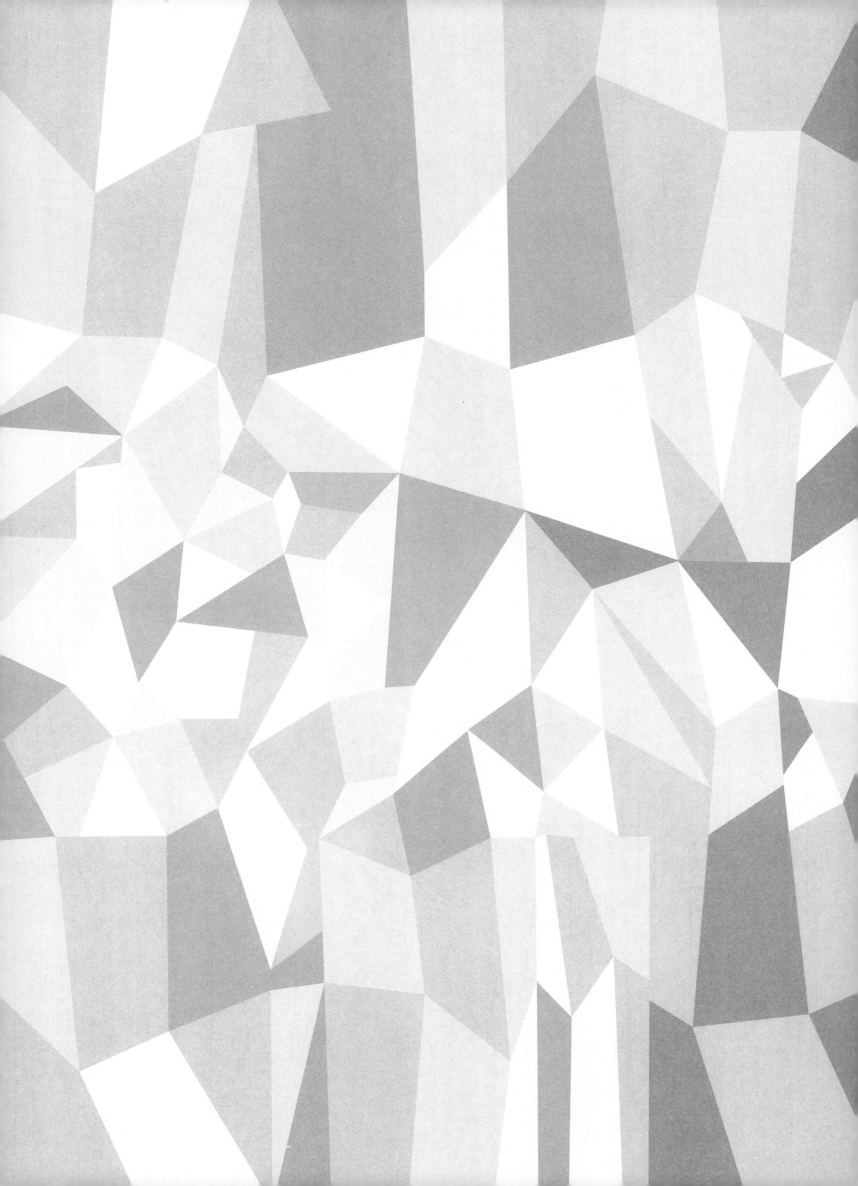

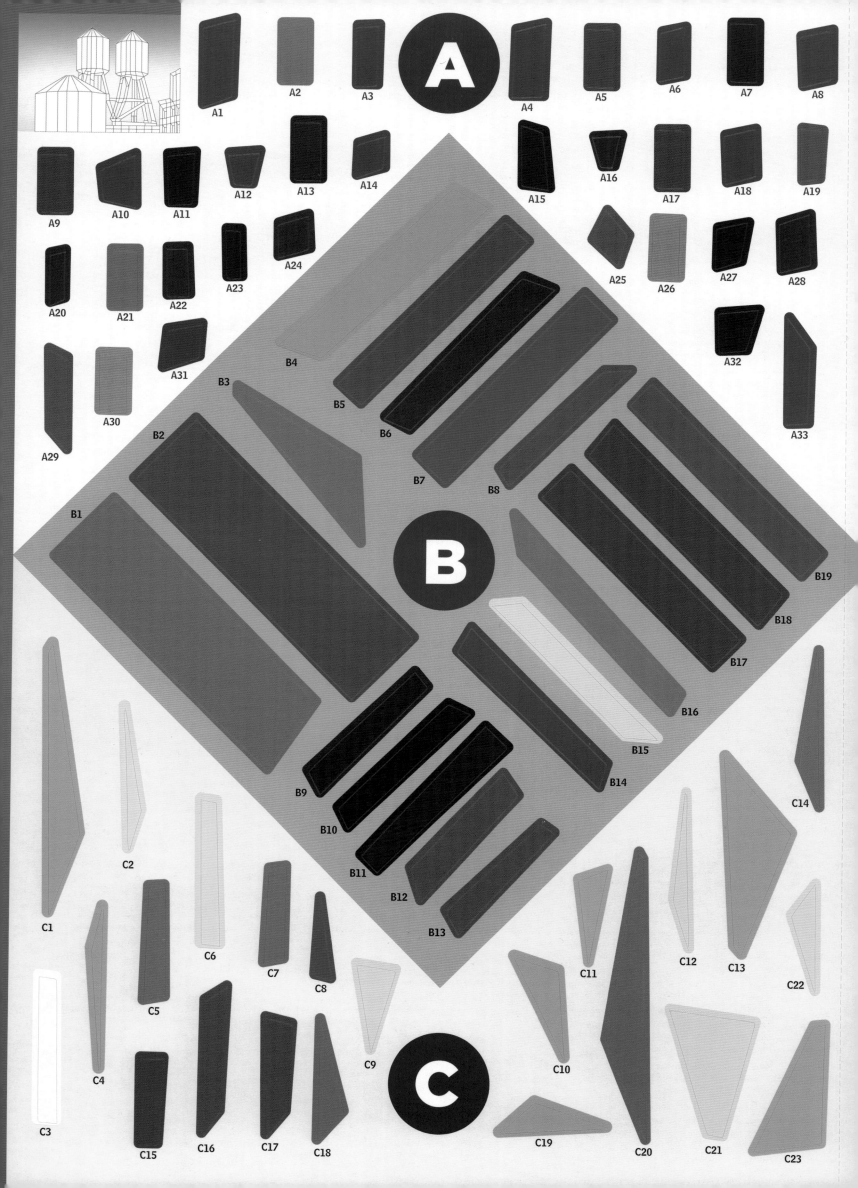

A

A1 A2 A3 A4 A5 A6 A7 A8
A9 A10 A11 A12 A13 A14 A15 A16 A17 A18 A19
A20 A21 A22 A23 A24 A25 A26 A27 A28
A29 A30 A31 A32 A33

B

B1 B2 B3 B4 B5 B6 B7 B8 B9 B10 B11 B12 B13 B14 B15 B16 B17 B18 B19

C

C1 C2 C3 C4 C5 C6 C7 C8 C9 C10 C11 C12 C13 C14 C15 C16 C17 C18 C19 C20 C21 C22 C23

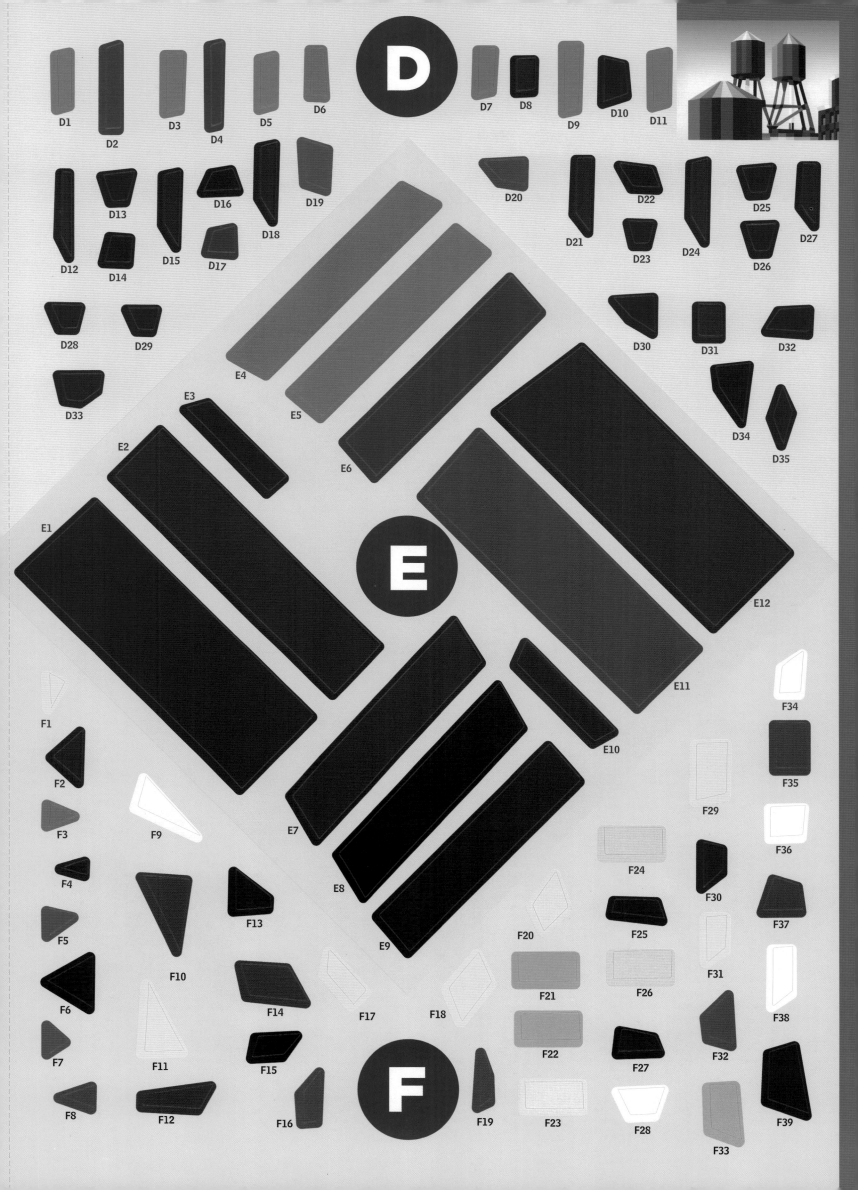

D

D1 D2 D3 D4 D5 D6 D7 D8 D9 D10 D11

D13 D16 D19 D20 D22 D25

D12 D15 D18 D21 D23 D24 D27

D14 D17 D26

D28 D29 D30 D31 D32

D33 D34

E4 D35

E3

E2 E5

E6

E1

E12

E

E11

F1 E10

F2

F3 F9 E7 F34

F4 F24 F35

F13 F29

F5 E8

F20 F30 F36

F6 F10 F25

F14 F21 F37

F7 F11 E9 F31

F17 F18 F26 F38

F8 F12 F15 F22 F27 F32

F16 F

F19 F23 F28 F39

F33

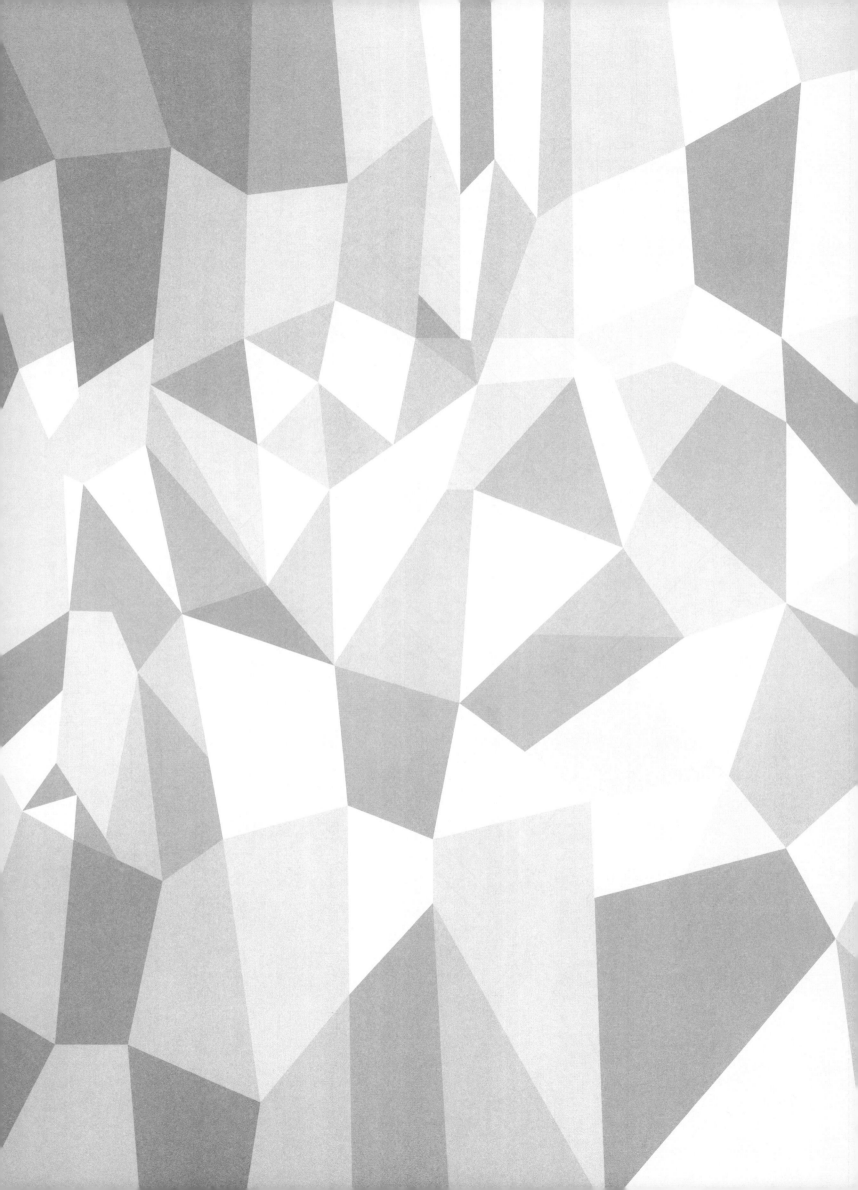

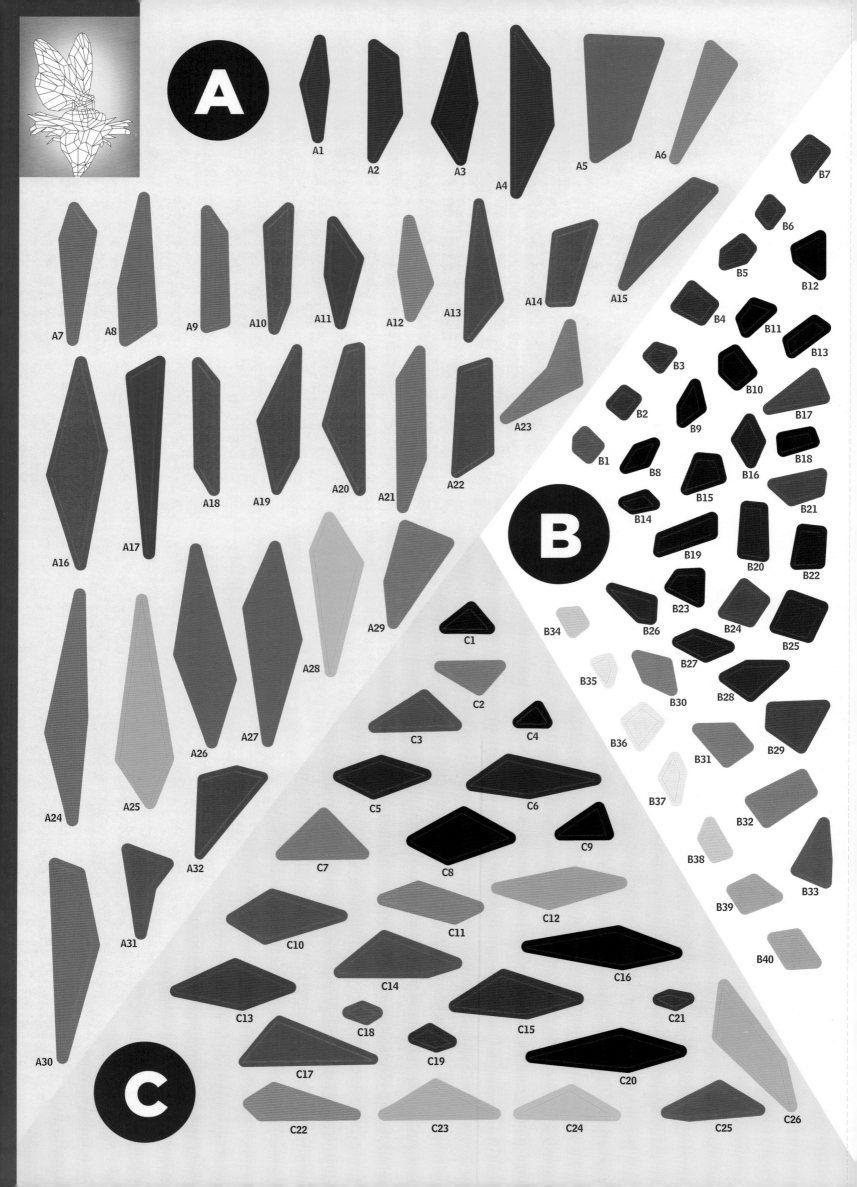

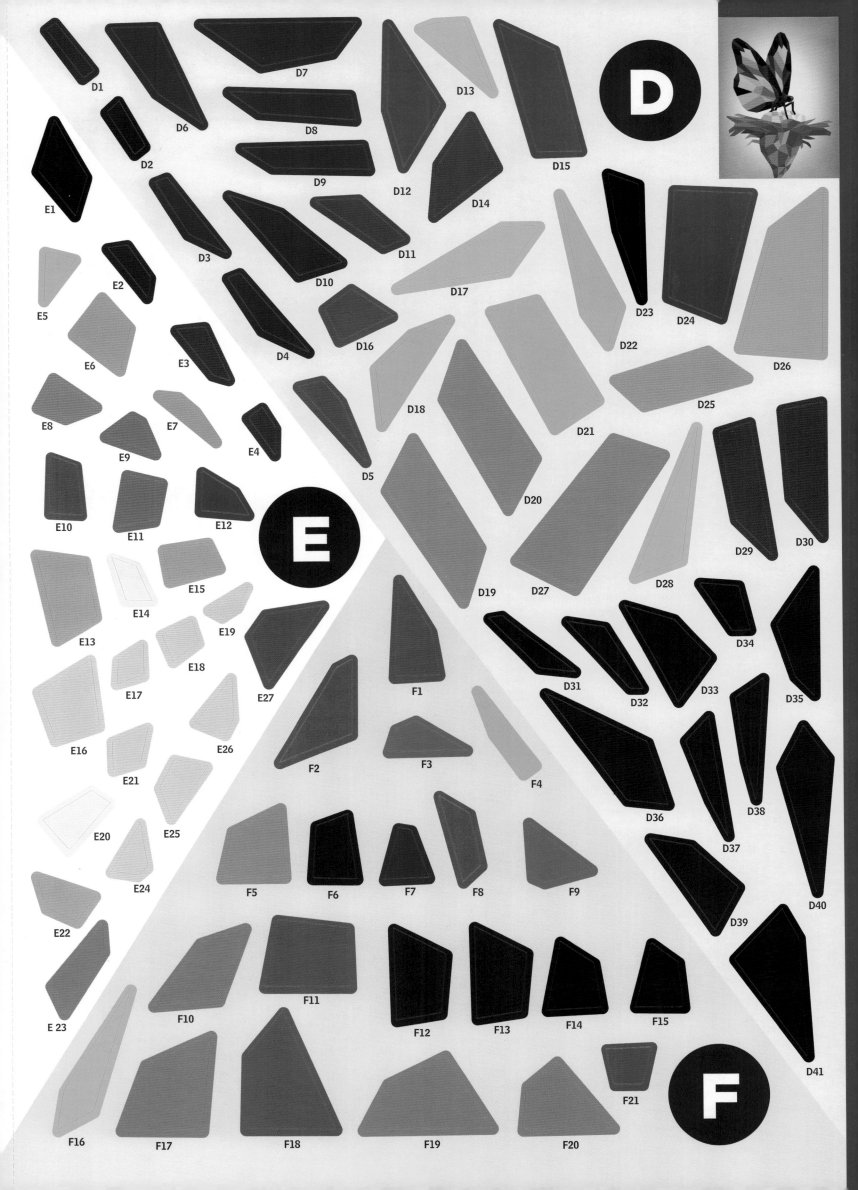

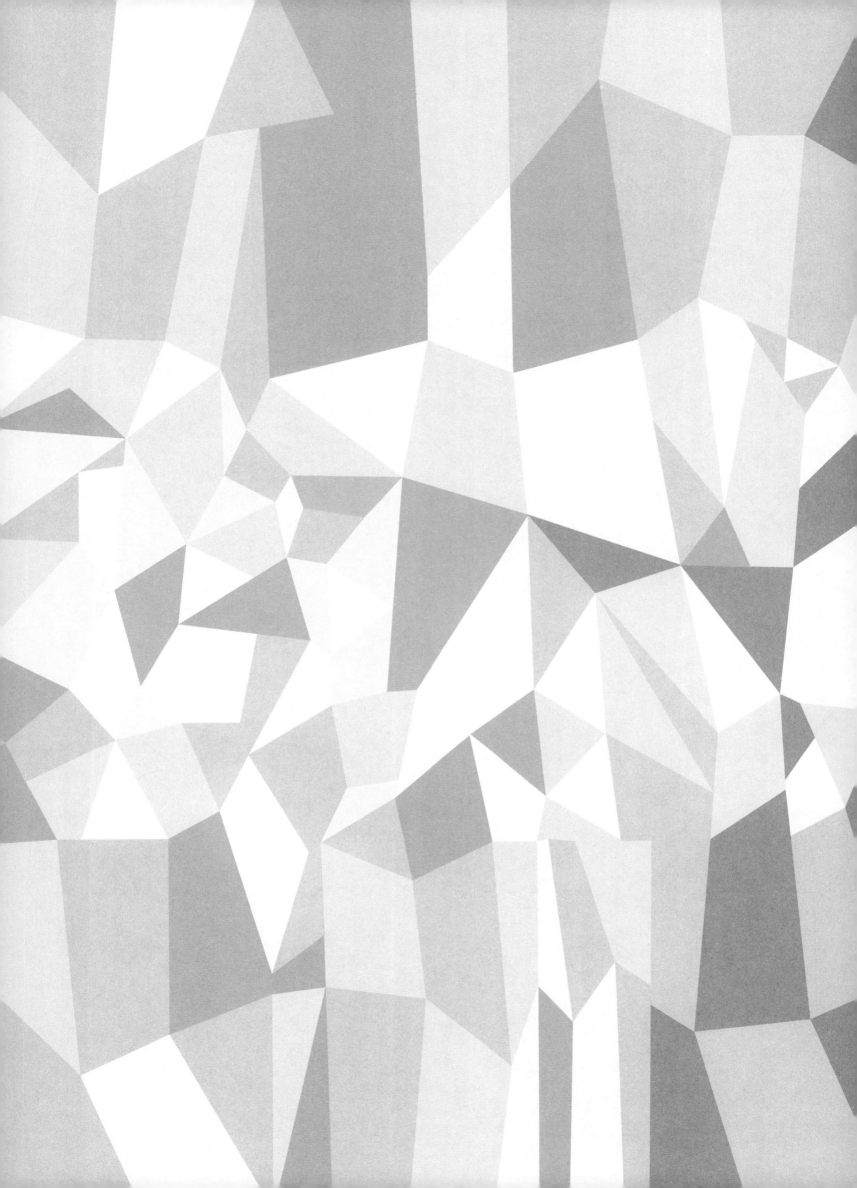

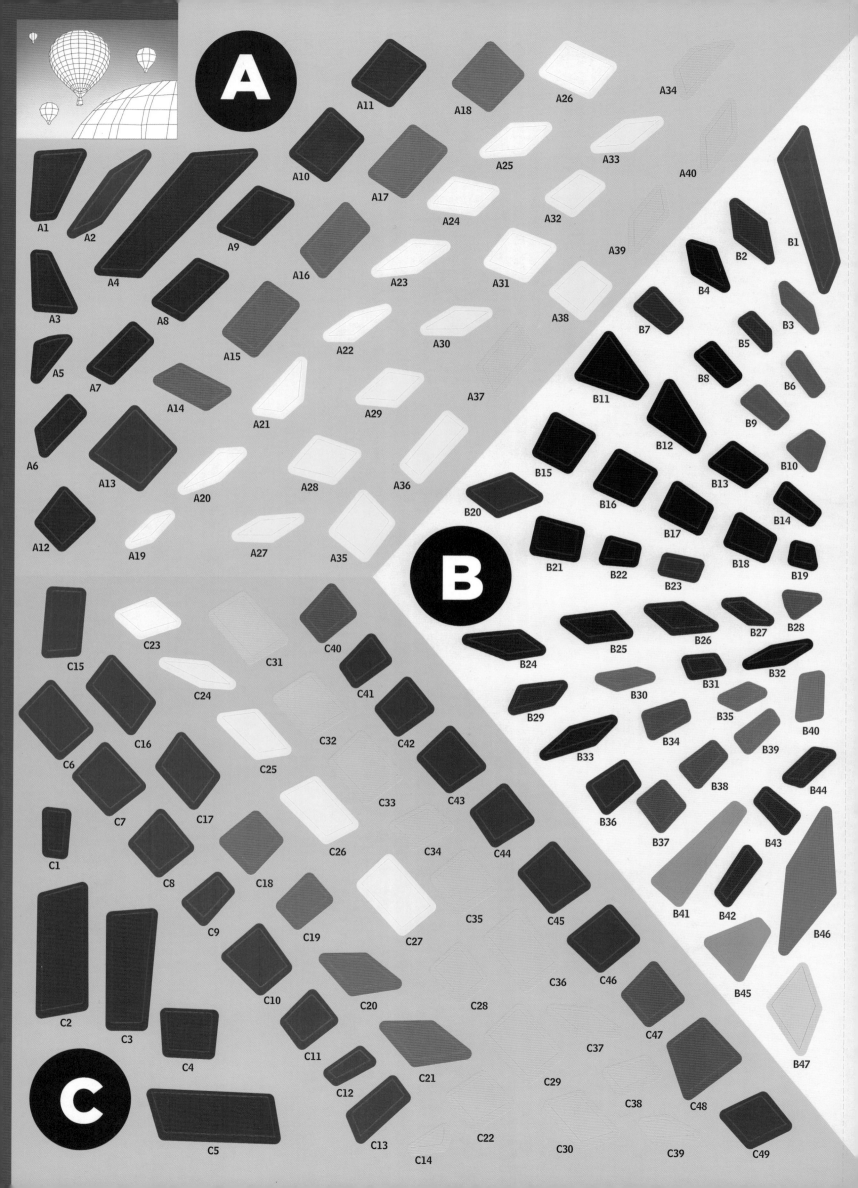

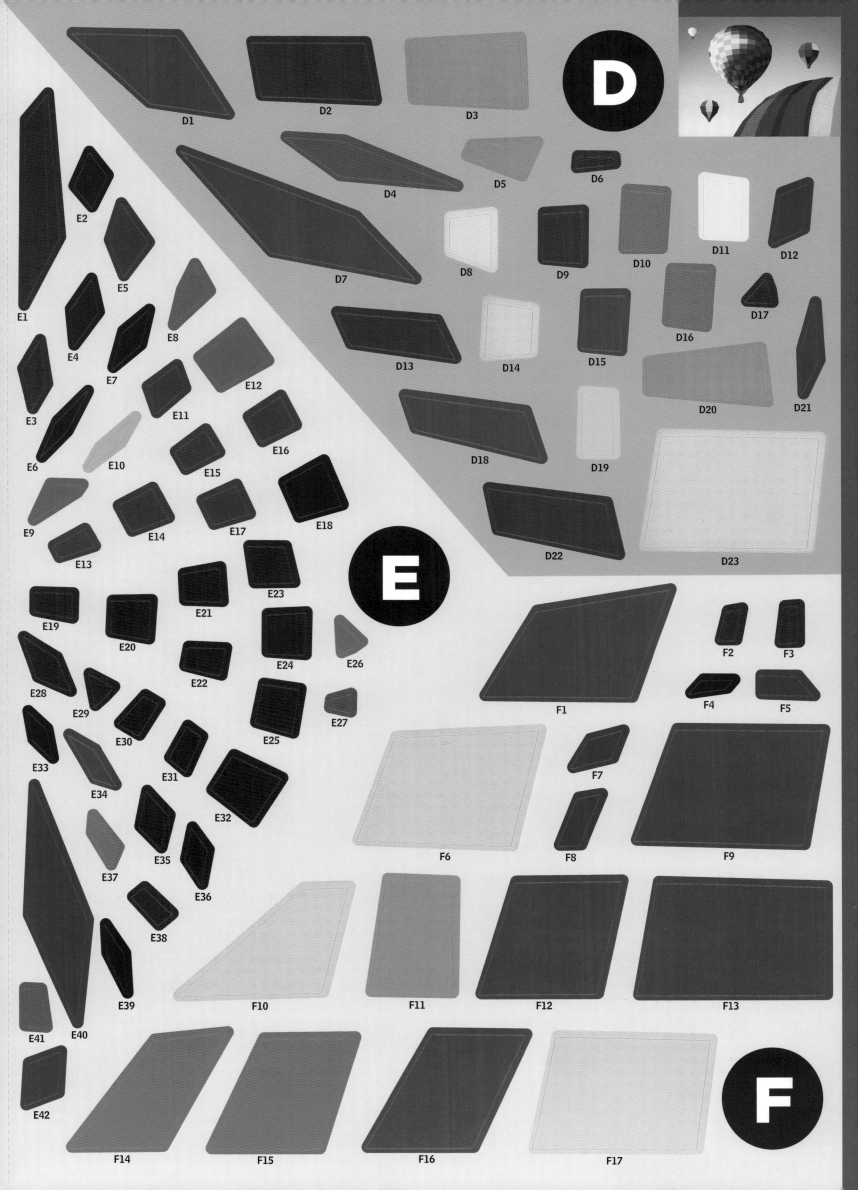

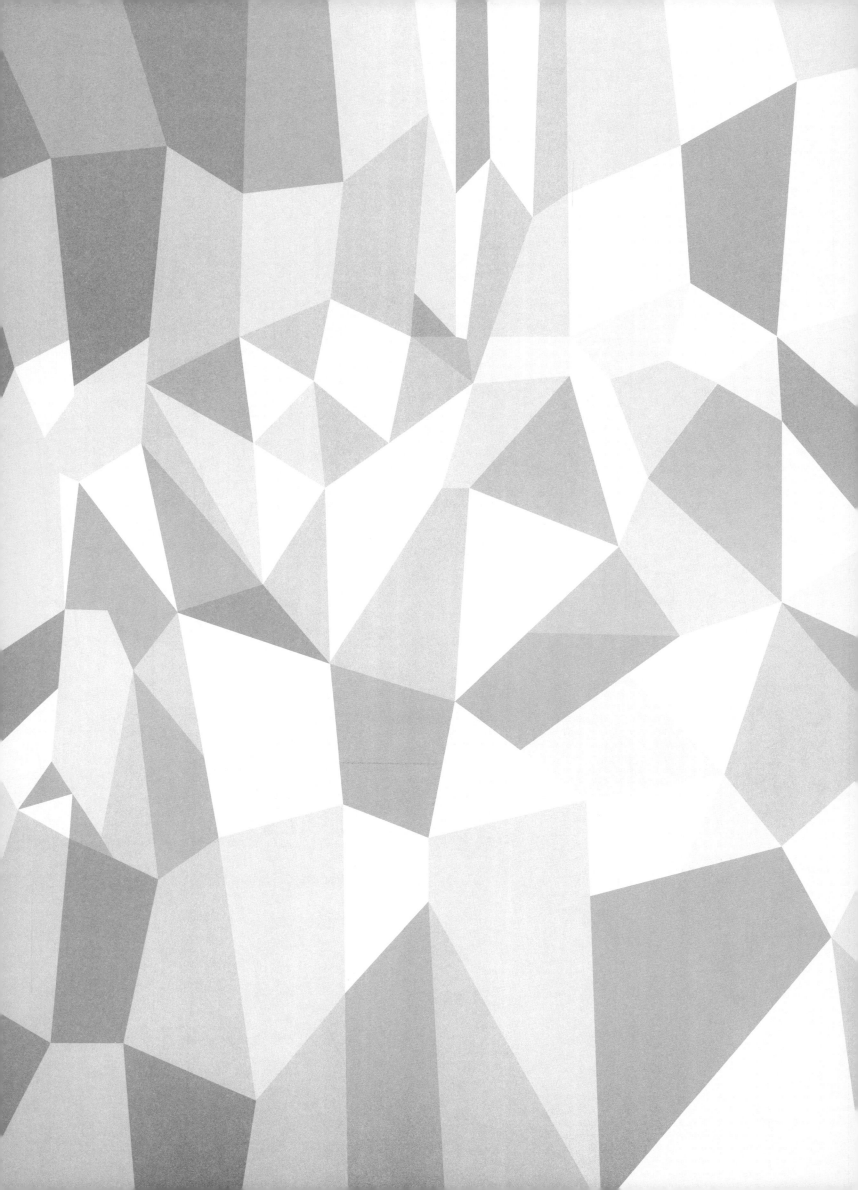

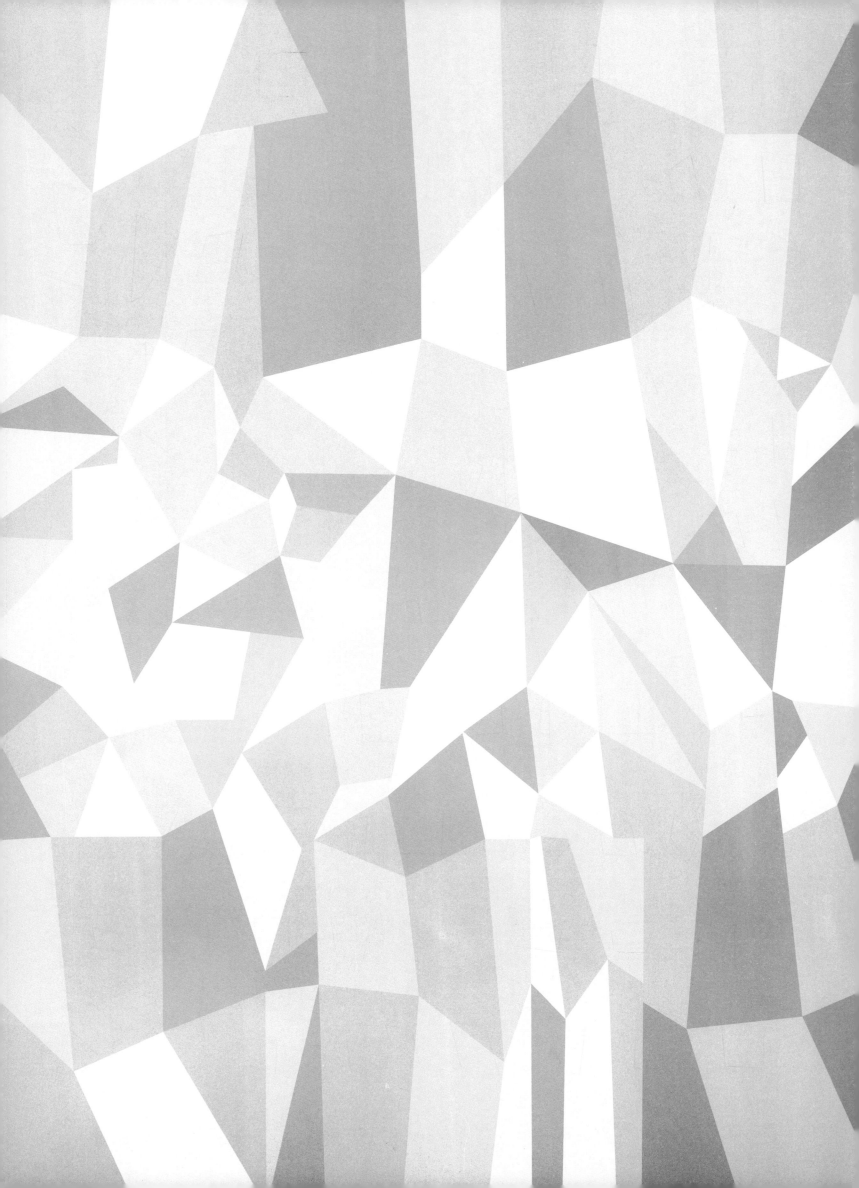

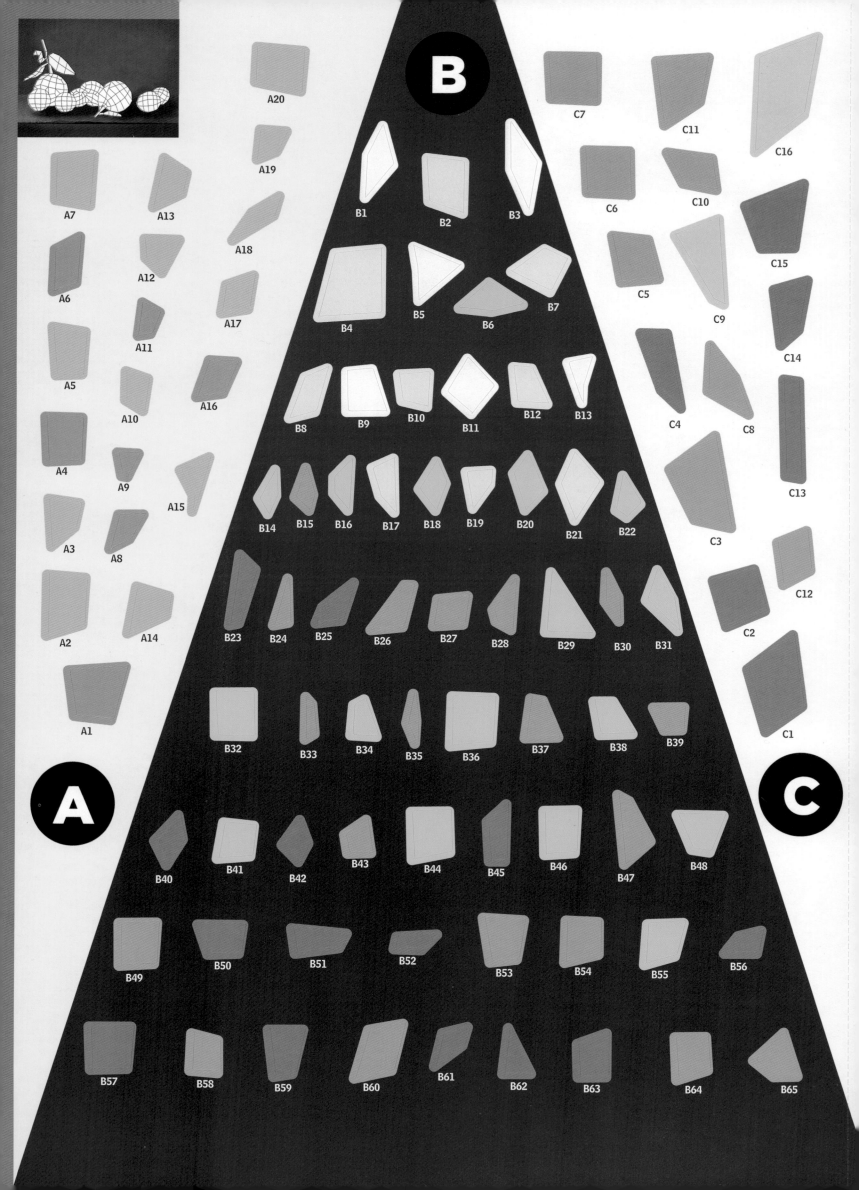

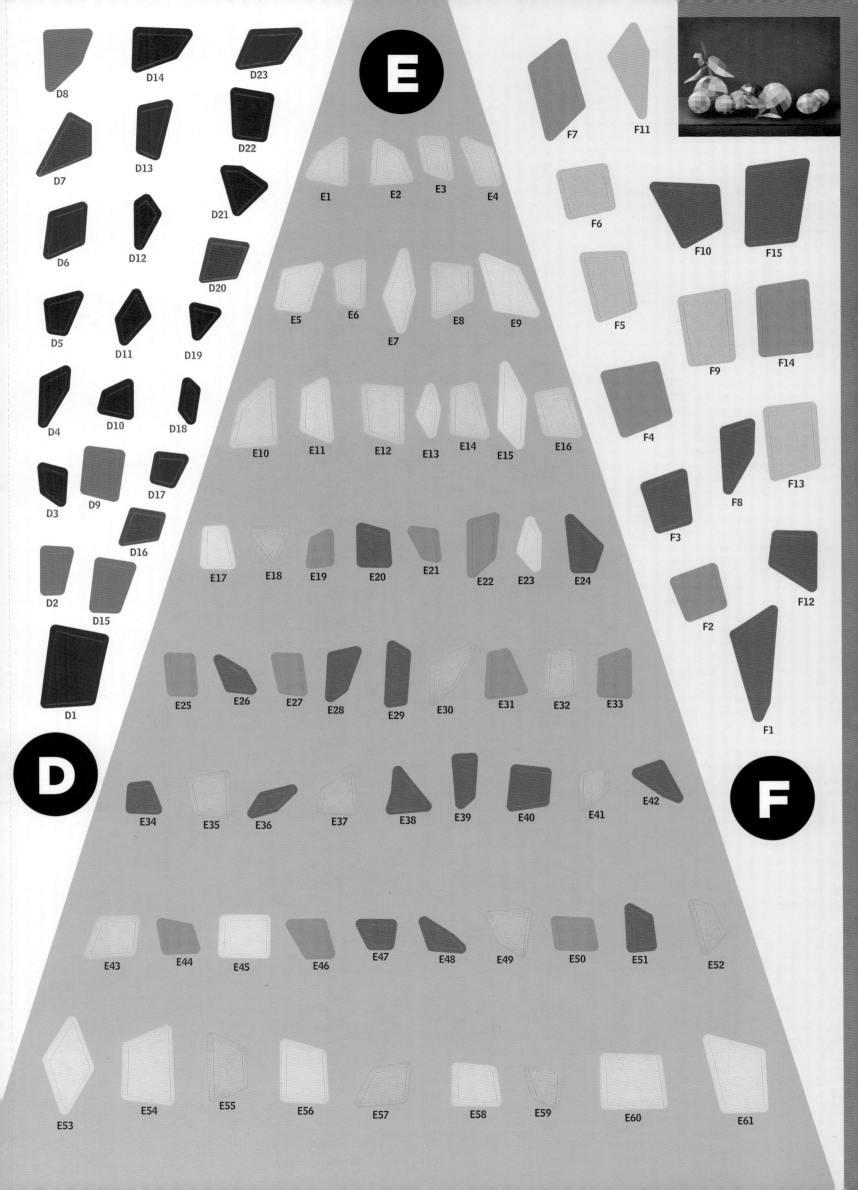

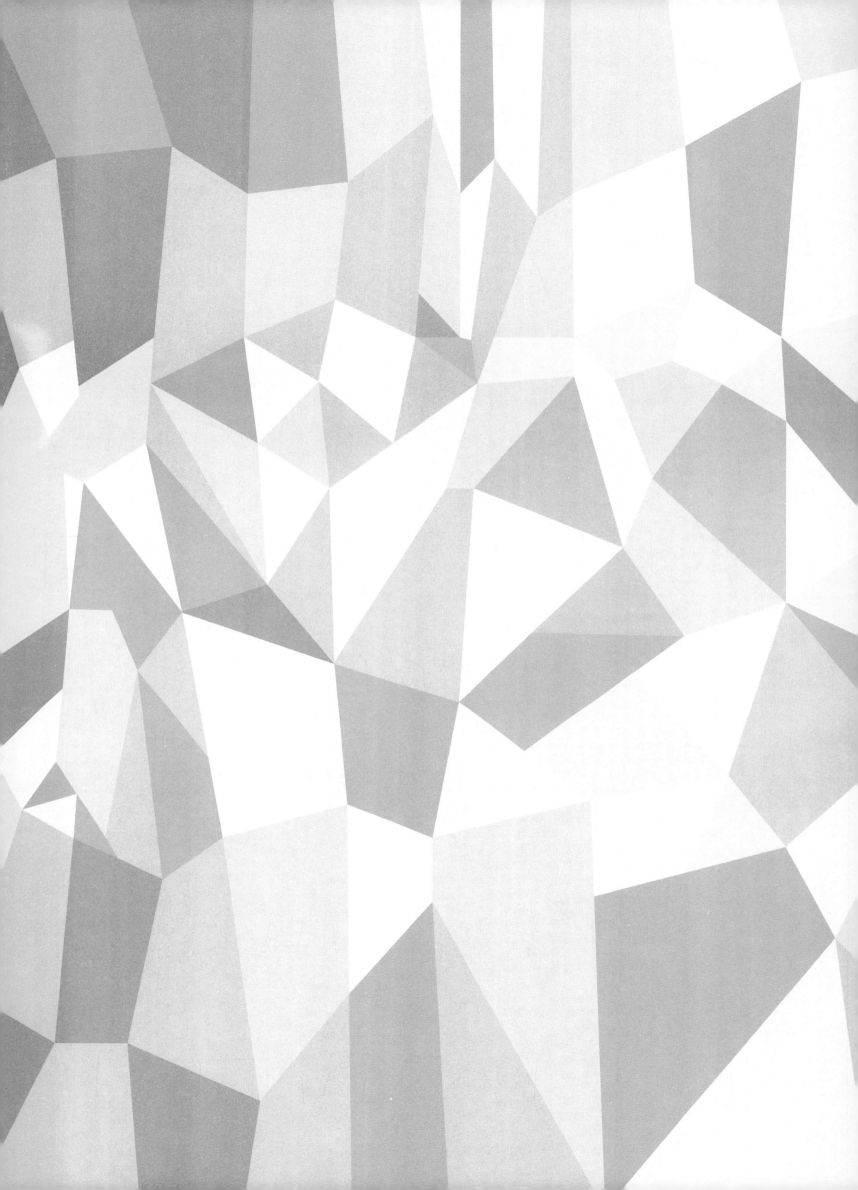

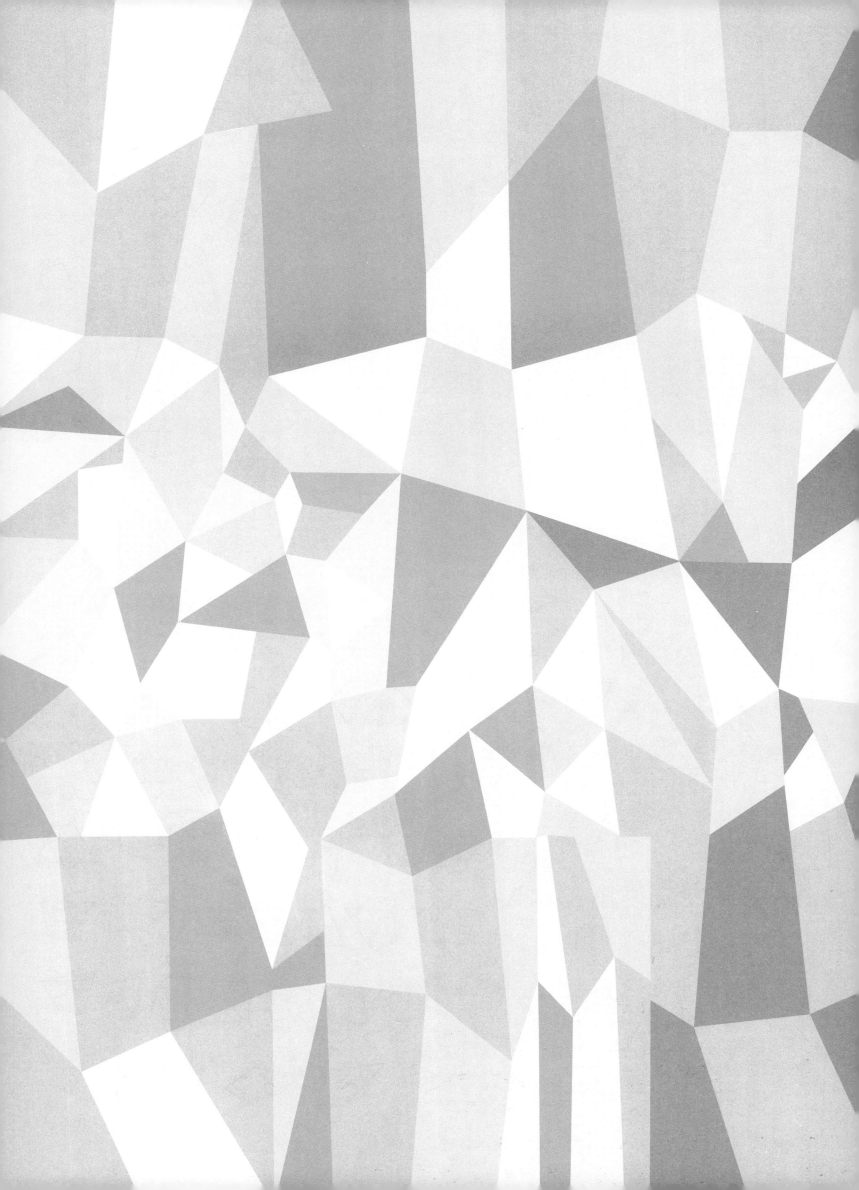

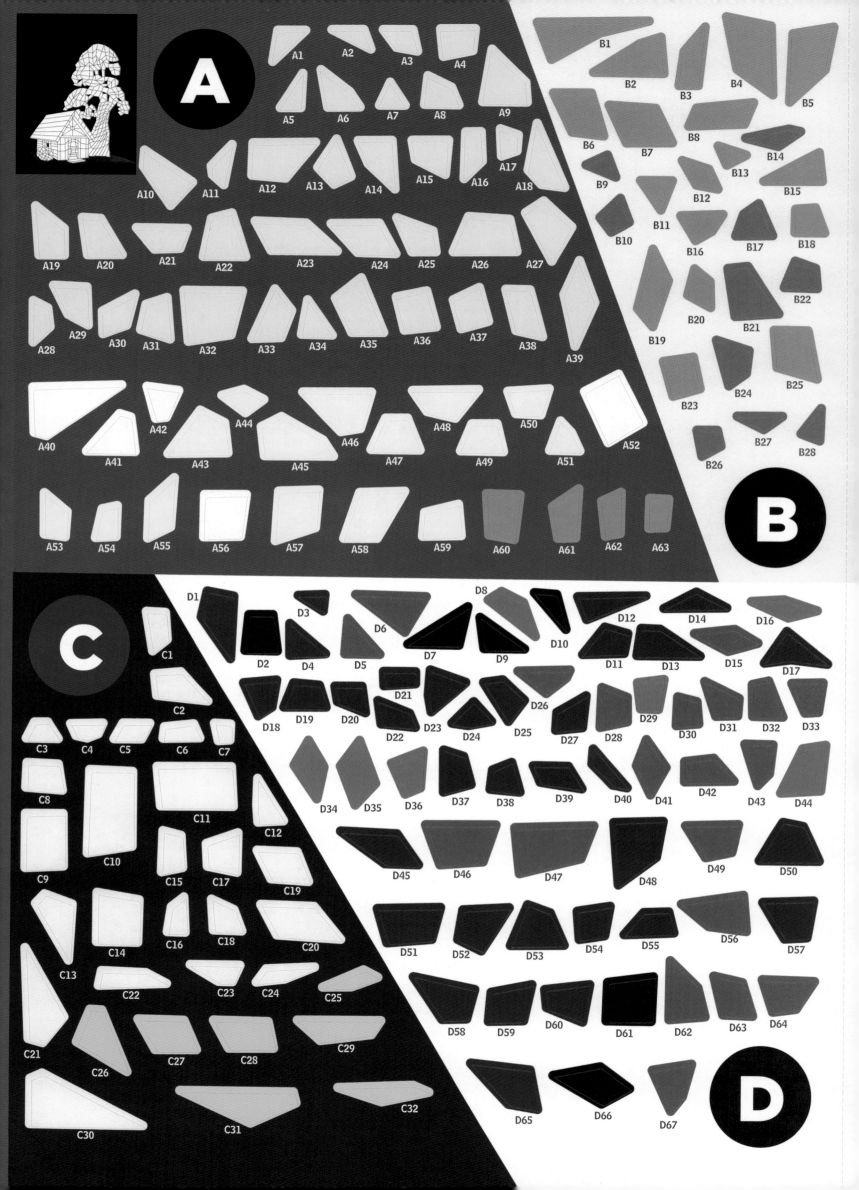

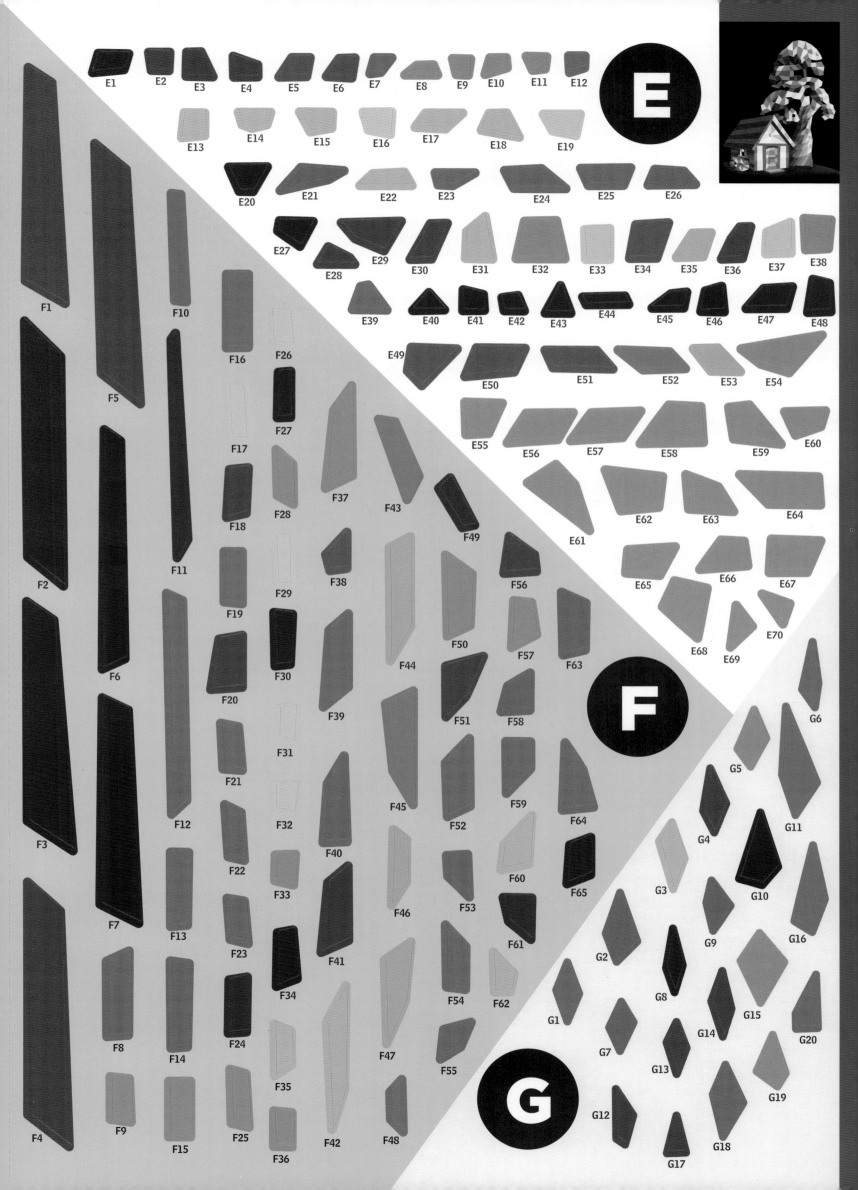

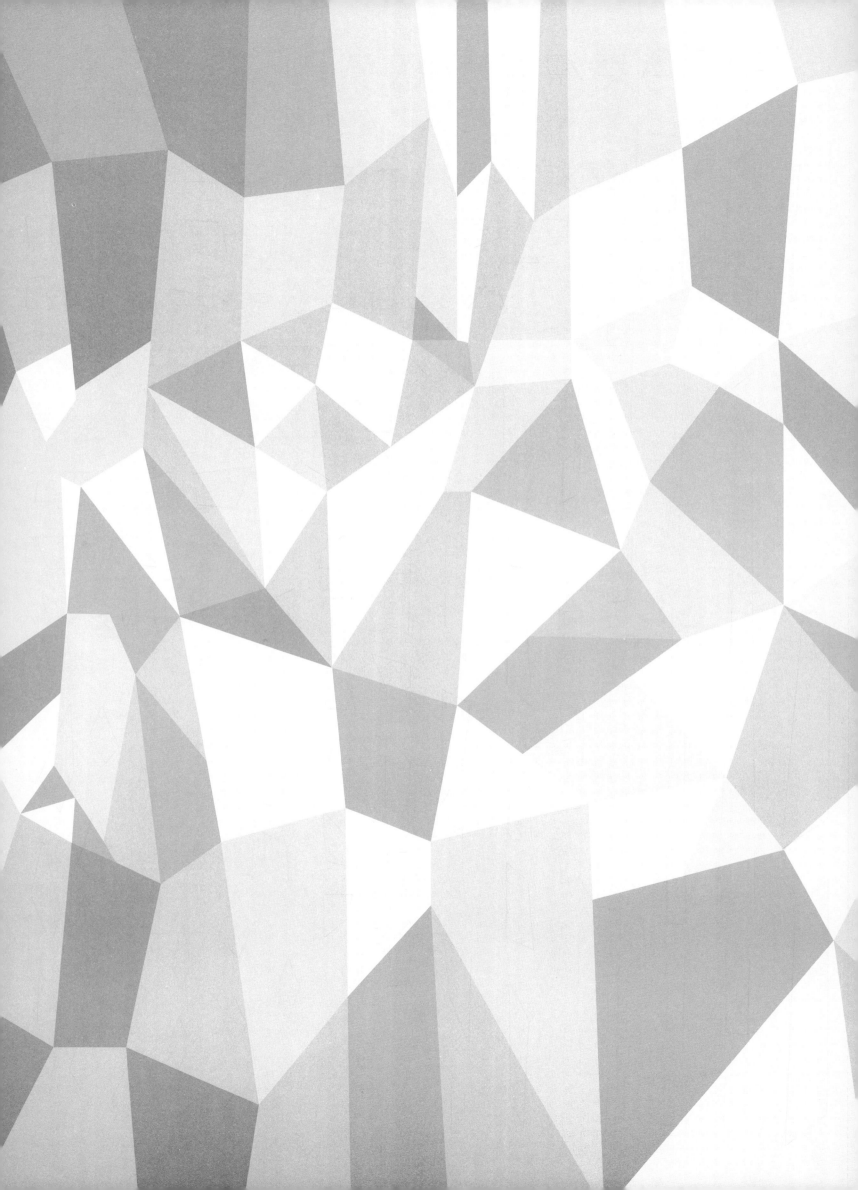

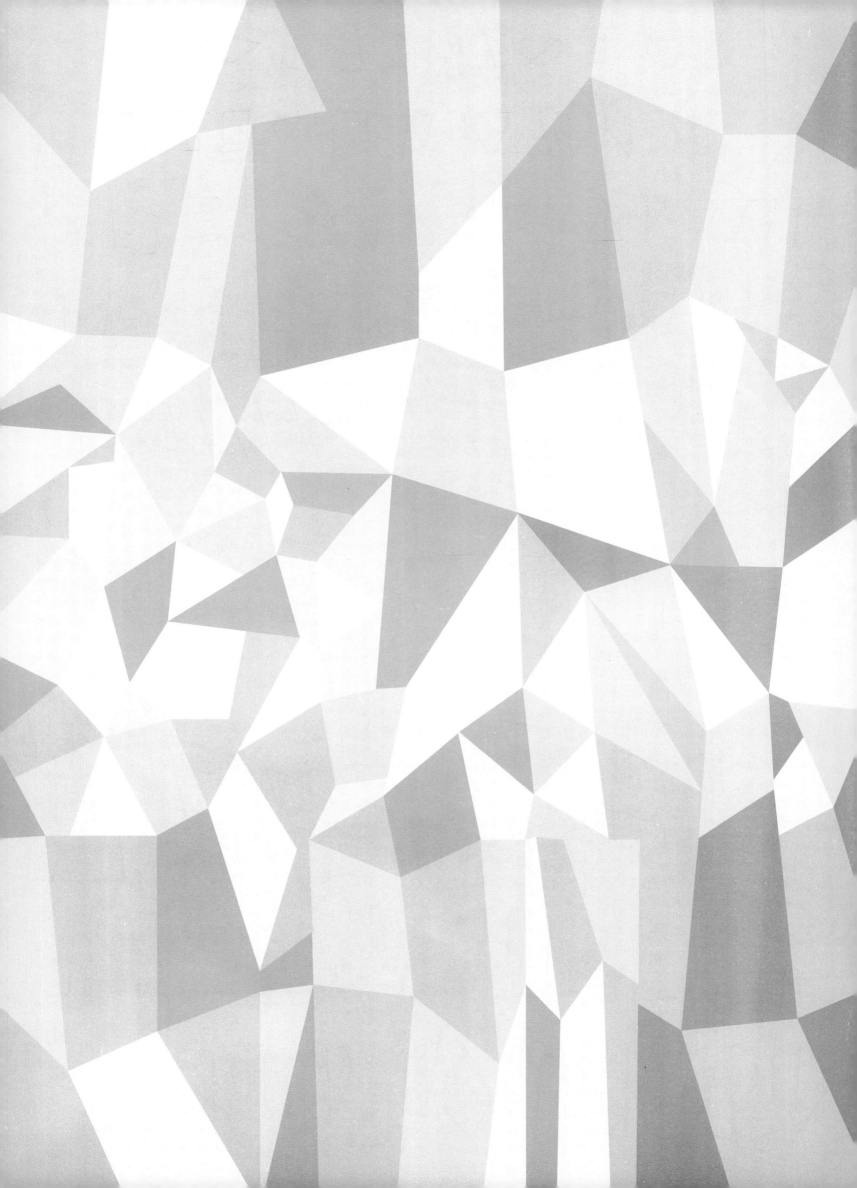

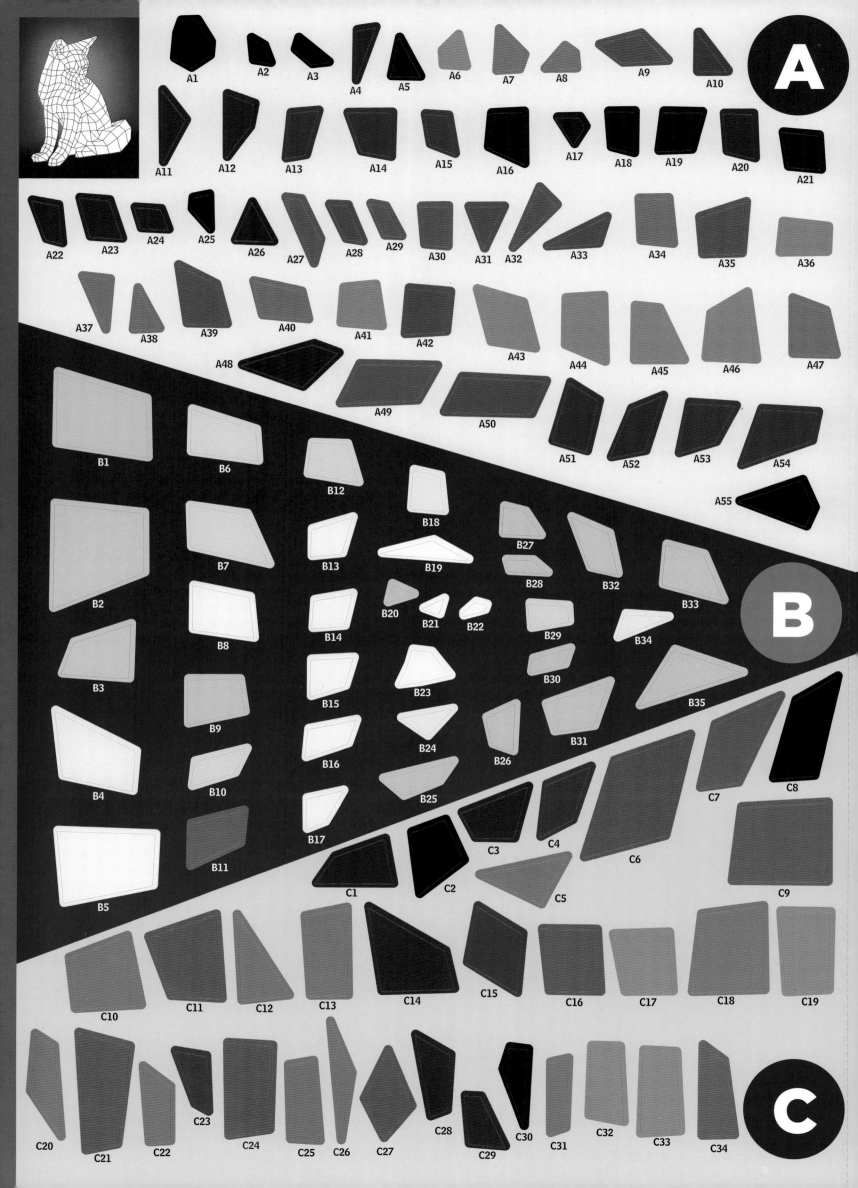

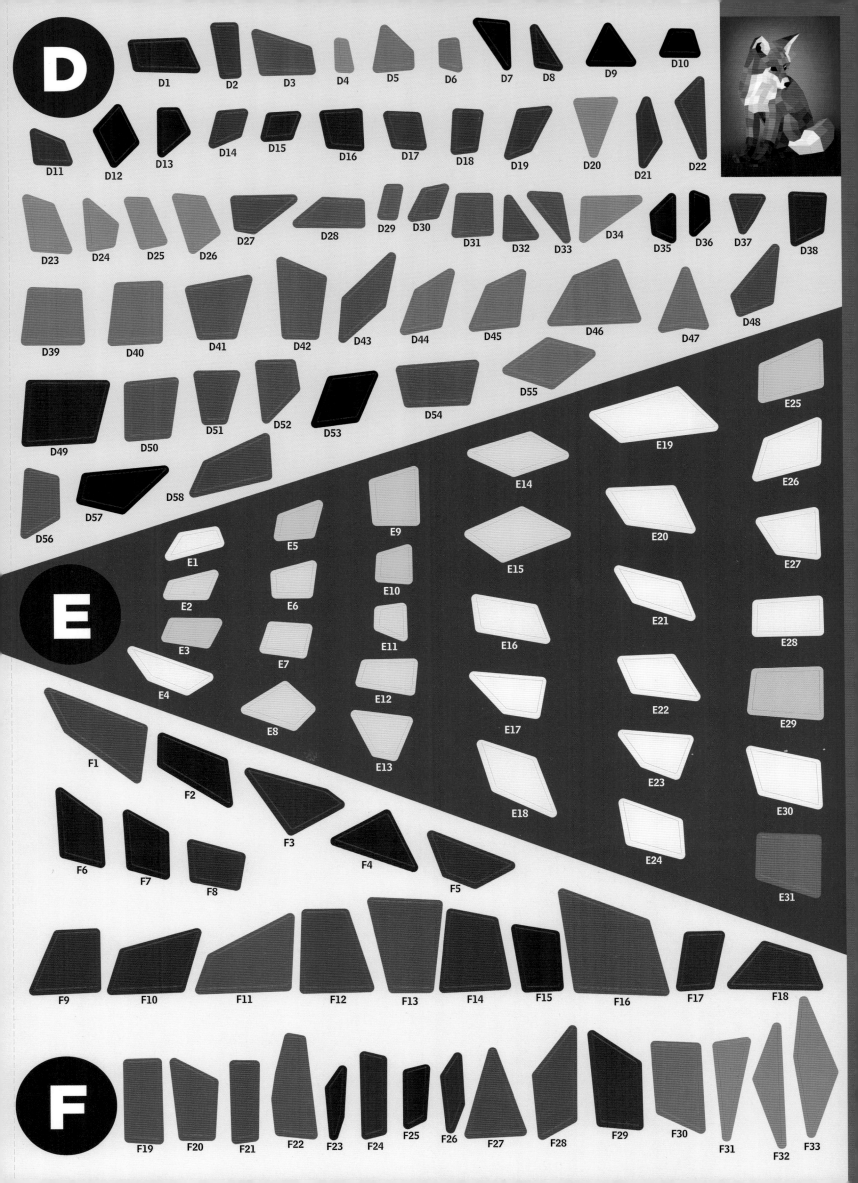

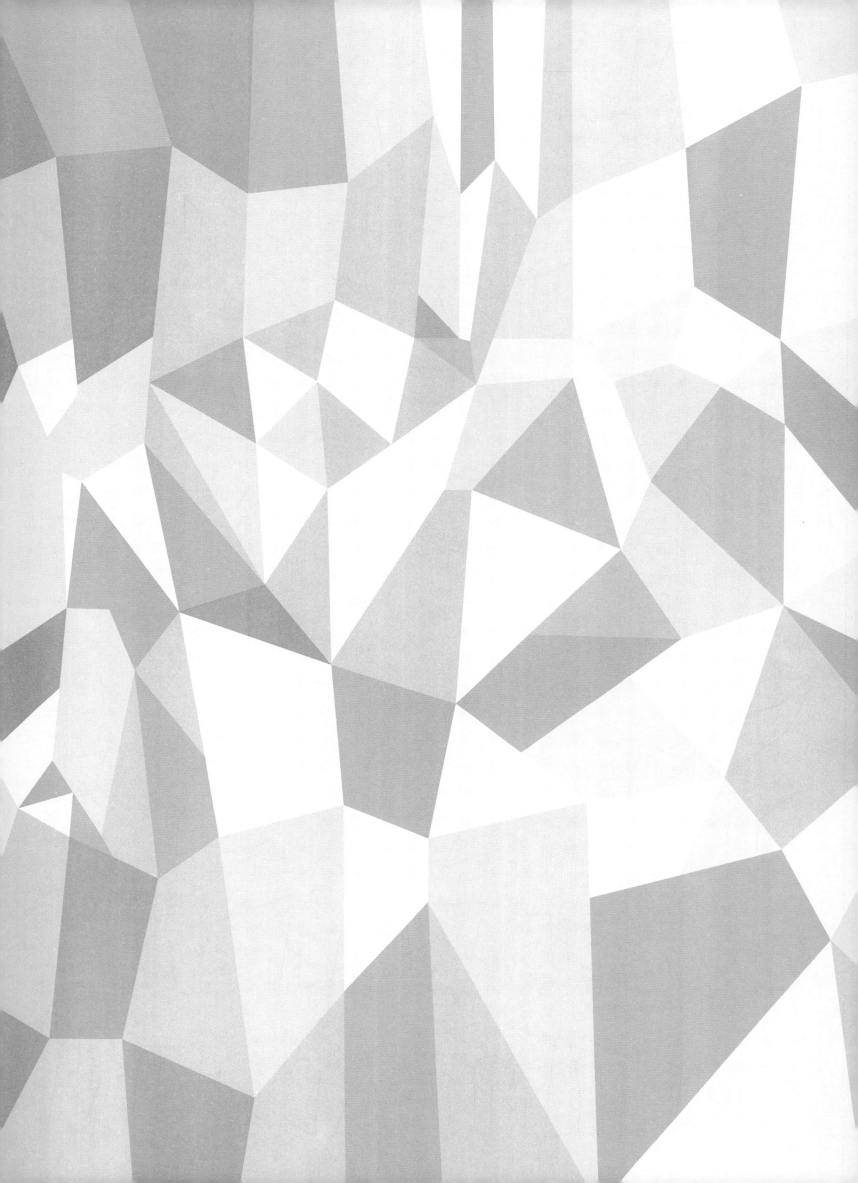

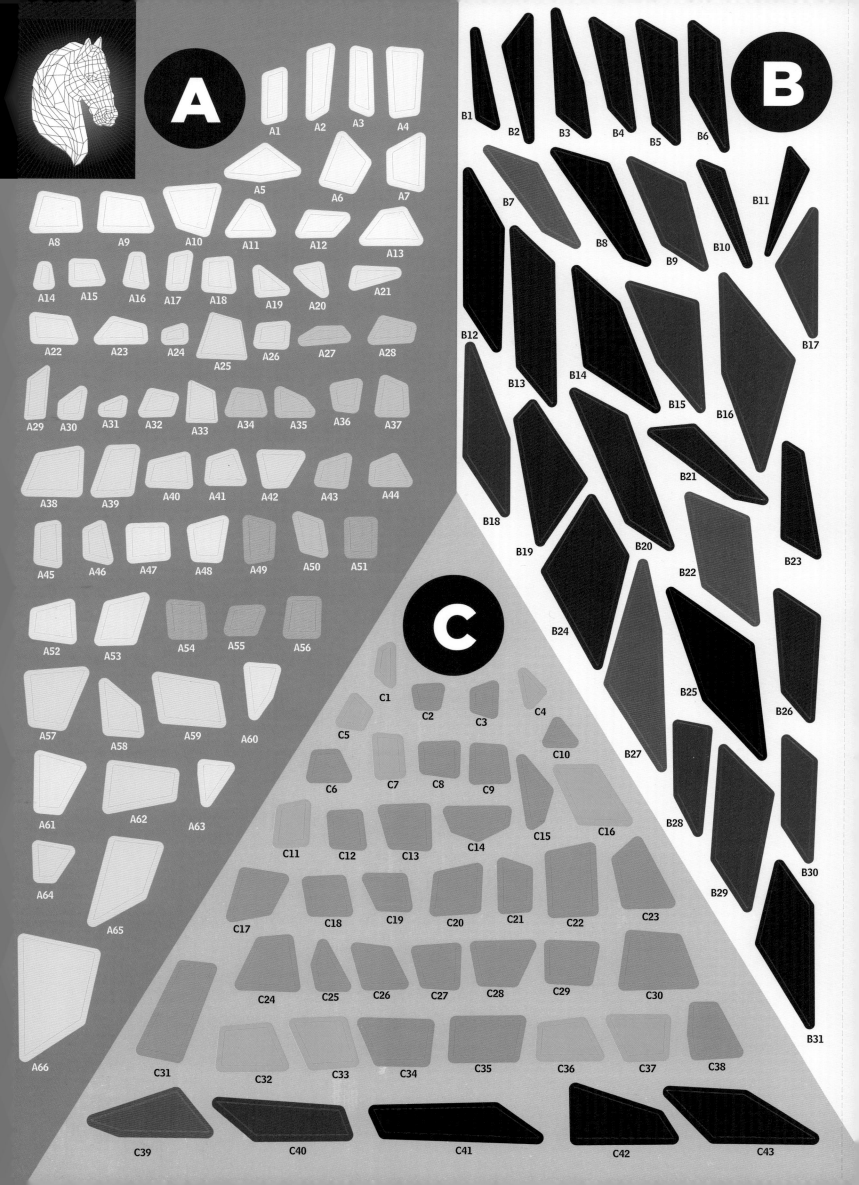

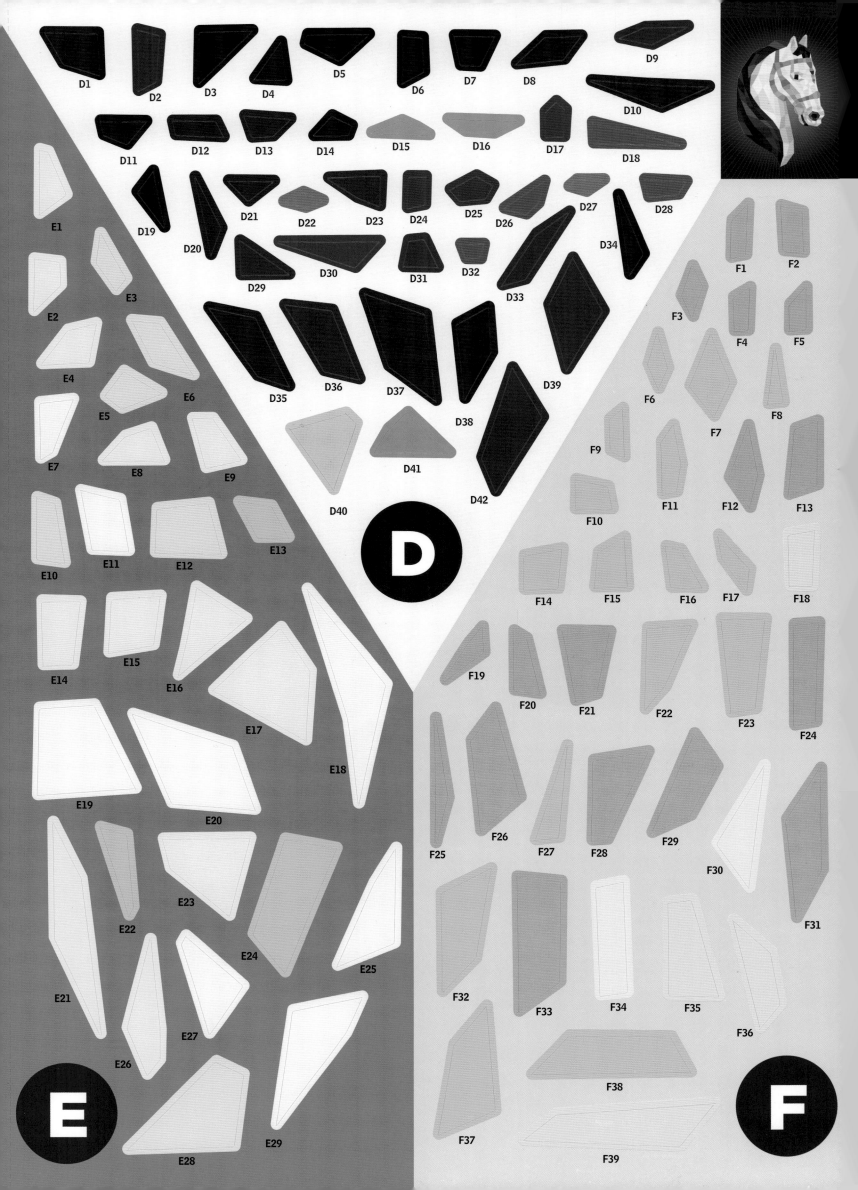

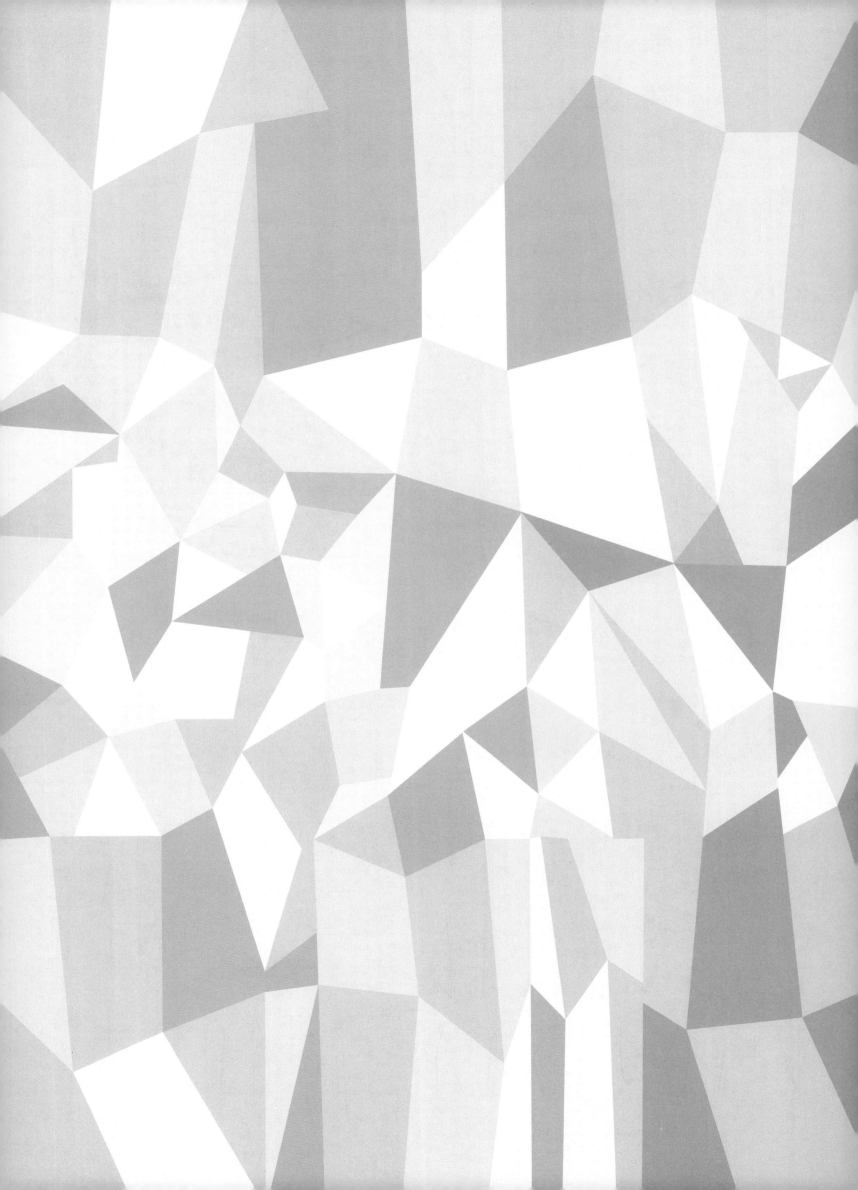

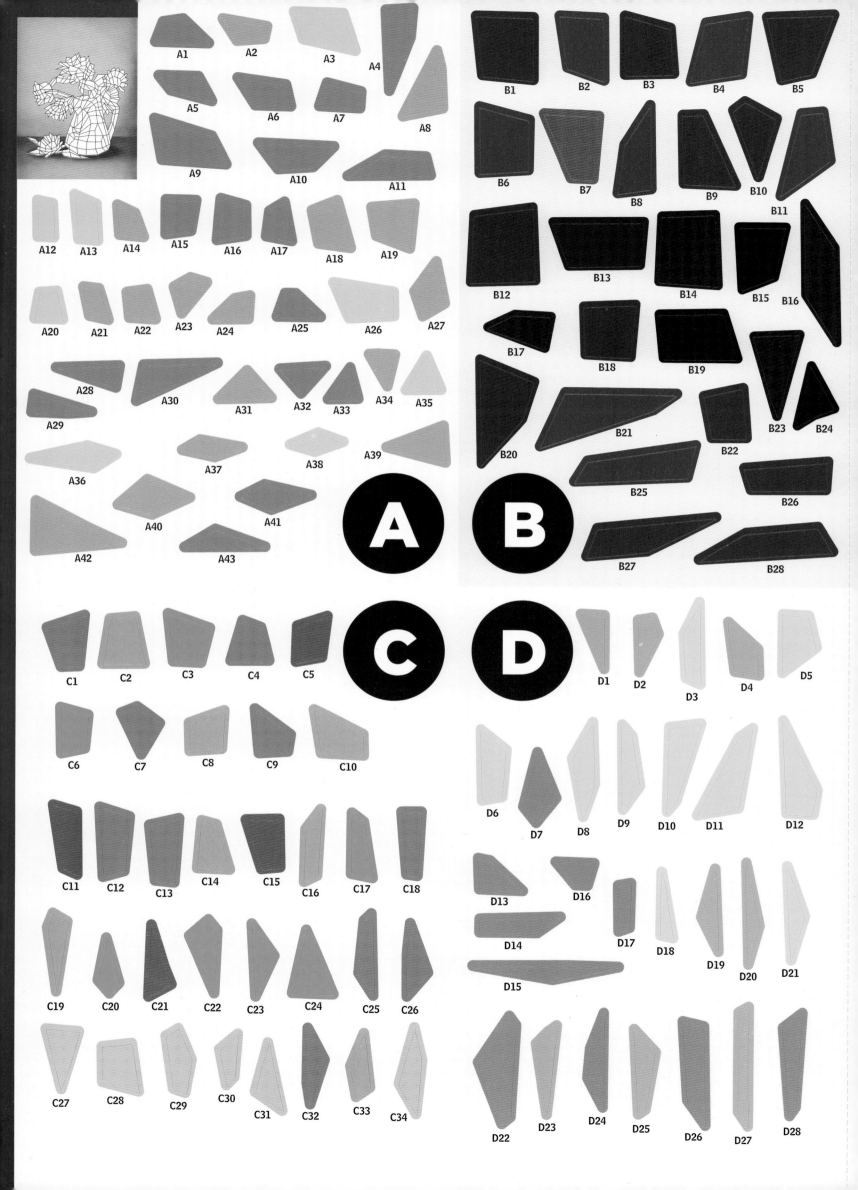

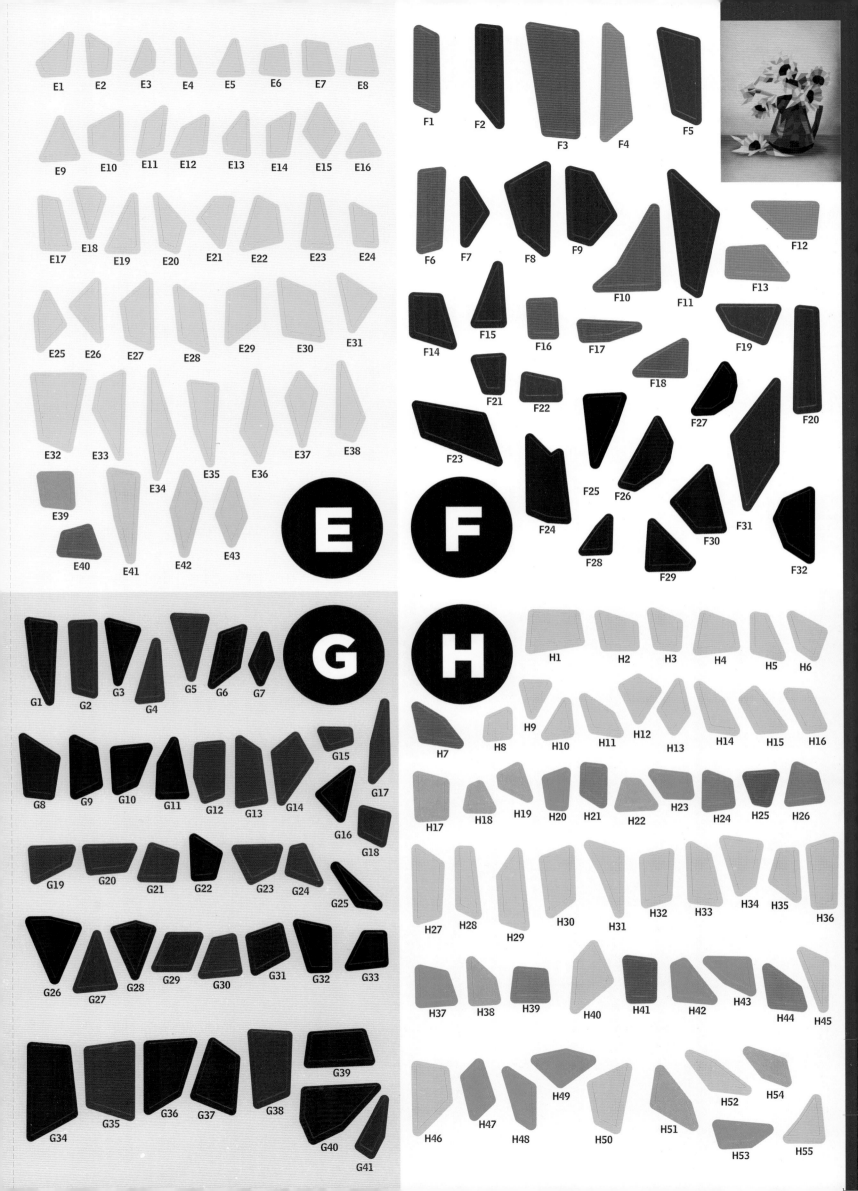

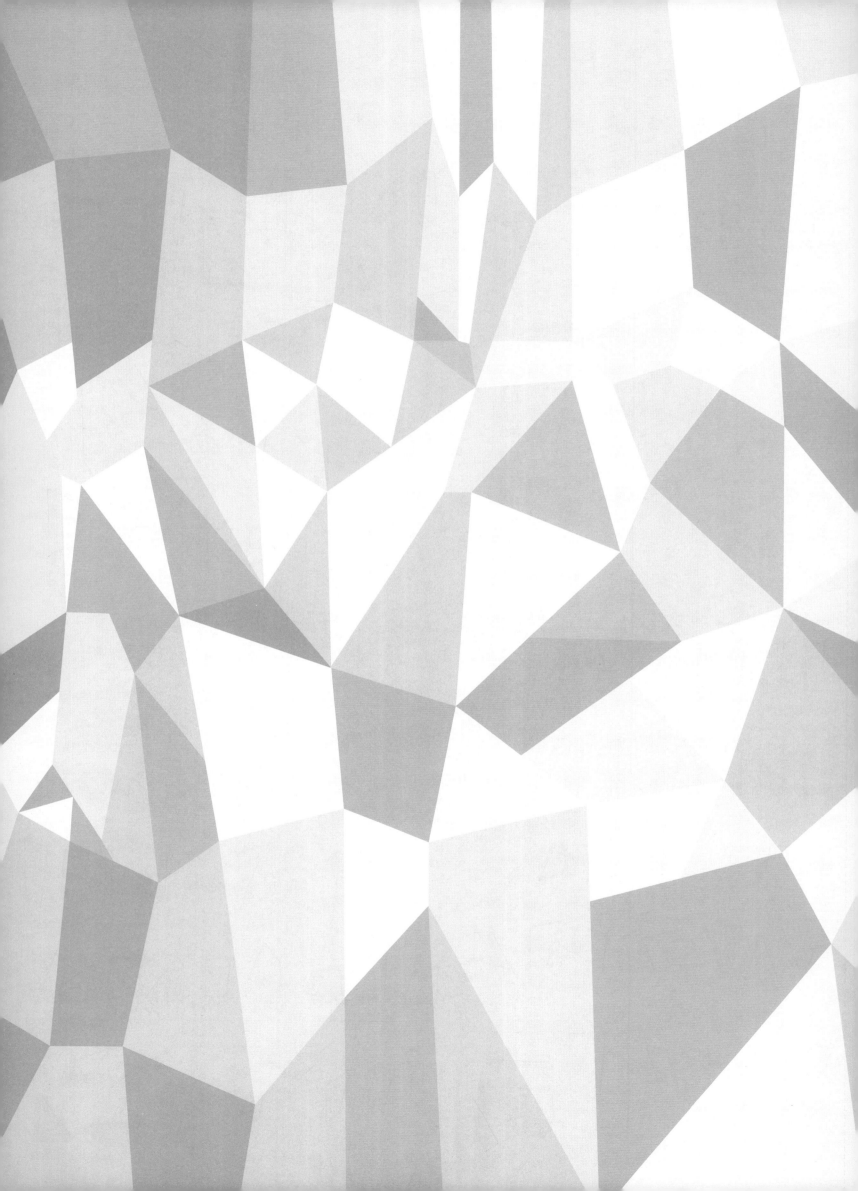

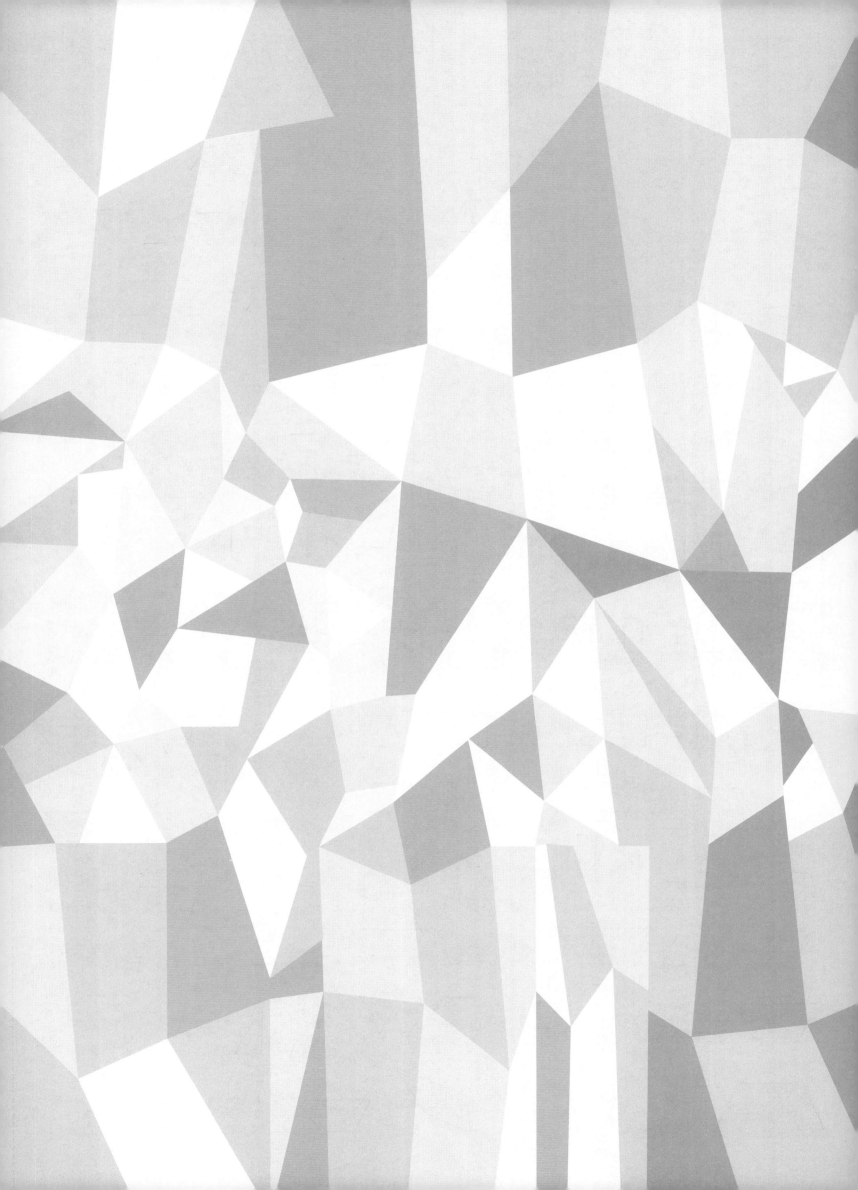

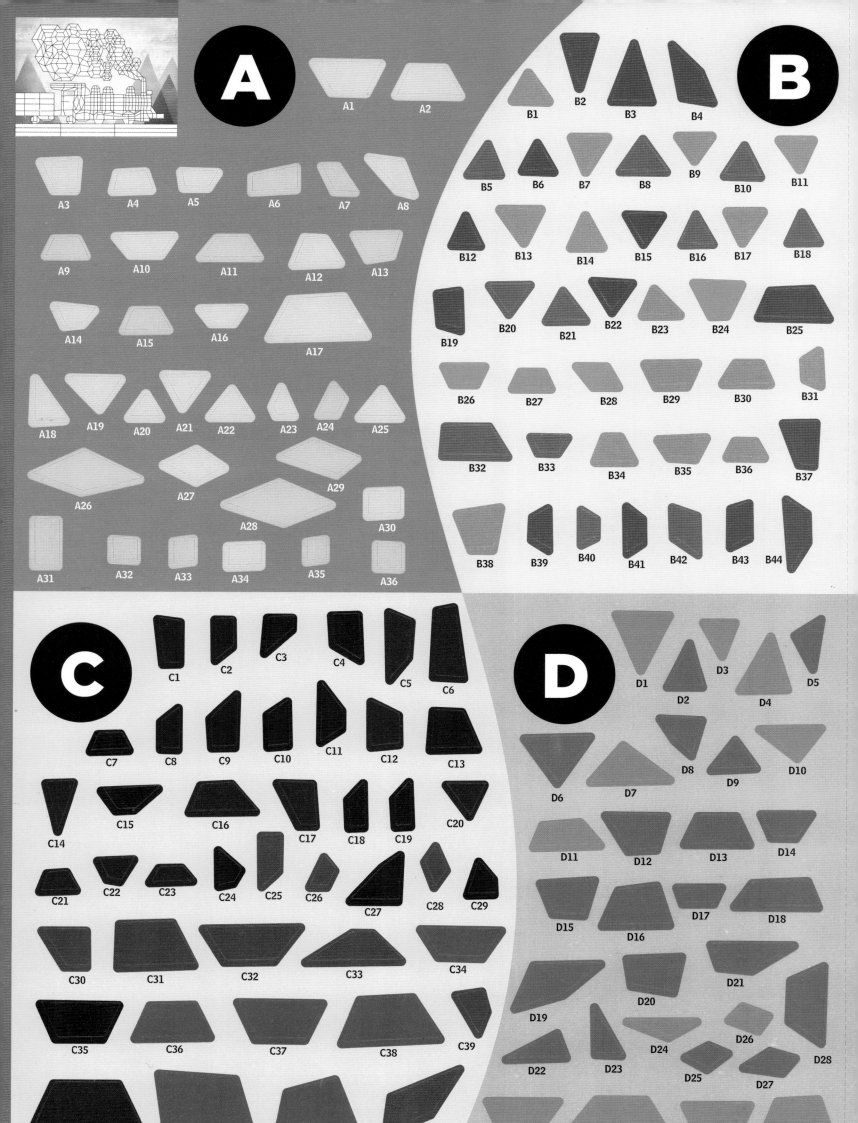

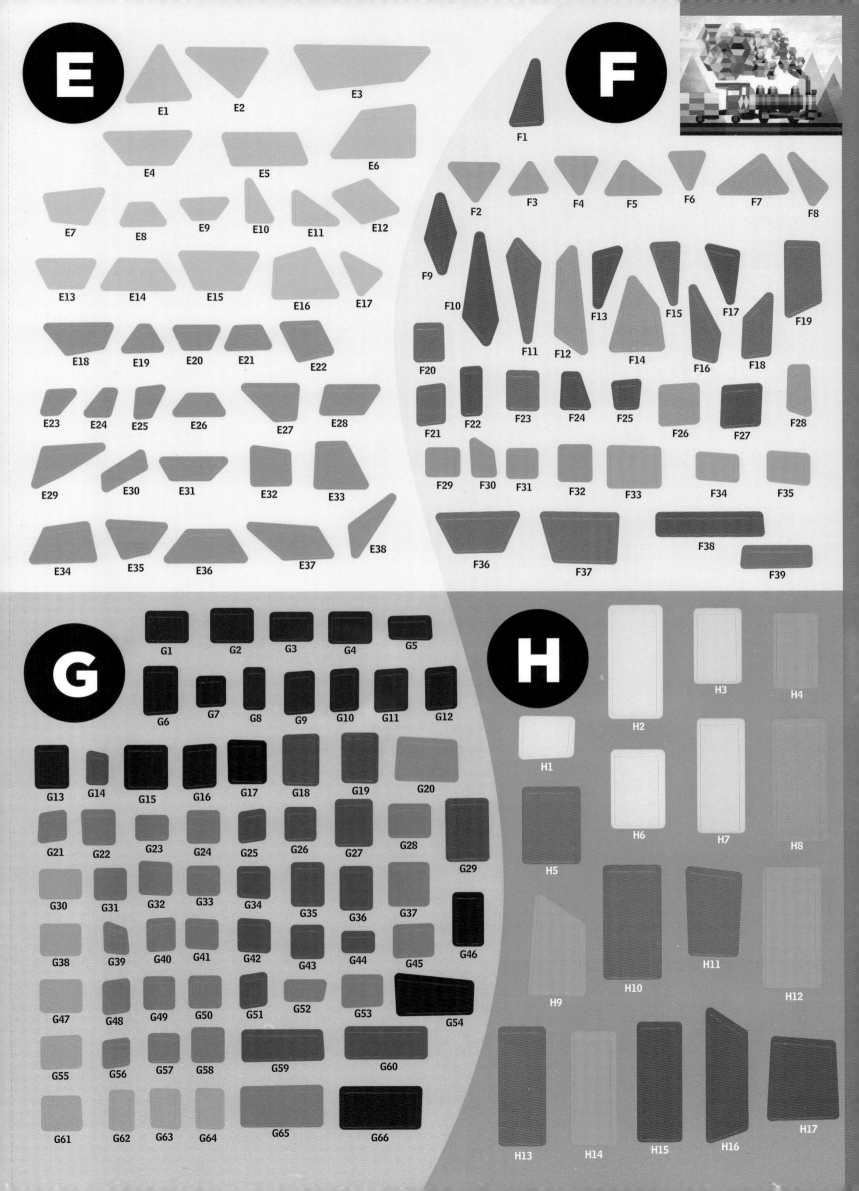

E

E1 E2 E3
E4 E5 E6
E7 E8 E9 E10 E11 E12
E13 E14 E15 E16 E17
E18 E19 E20 E21 E22
E23 E24 E25 E26 E27 E28
E29 E30 E31 E32 E33
E34 E35 E36 E37 E38

F

F1
F2 F3 F4 F5 F6 F7 F8
F9 F10 F11 F12 F13 F14 F15 F16 F17 F18 F19
F20 F21 F22 F23 F24 F25 F26 F27 F28
F29 F30 F31 F32 F33 F34 F35
F36 F37 F38 F39

G

G1 G2 G3 G4 G5
G6 G7 G8 G9 G10 G11 G12
G13 G14 G15 G16 G17 G18 G19 G20
G21 G22 G23 G24 G25 G26 G27 G28 G29
G30 G31 G32 G33 G34 G35 G36 G37 G46
G38 G39 G40 G41 G42 G43 G44 G45 G54
G47 G48 G49 G50 G51 G52 G53
G55 G56 G57 G58 G59 G60
G61 G62 G63 G64 G65 G66

H

H1 H2 H3 H4
H5 H6 H7 H8
H9 H10 H11 H12
H13 H14 H15 H16 H17

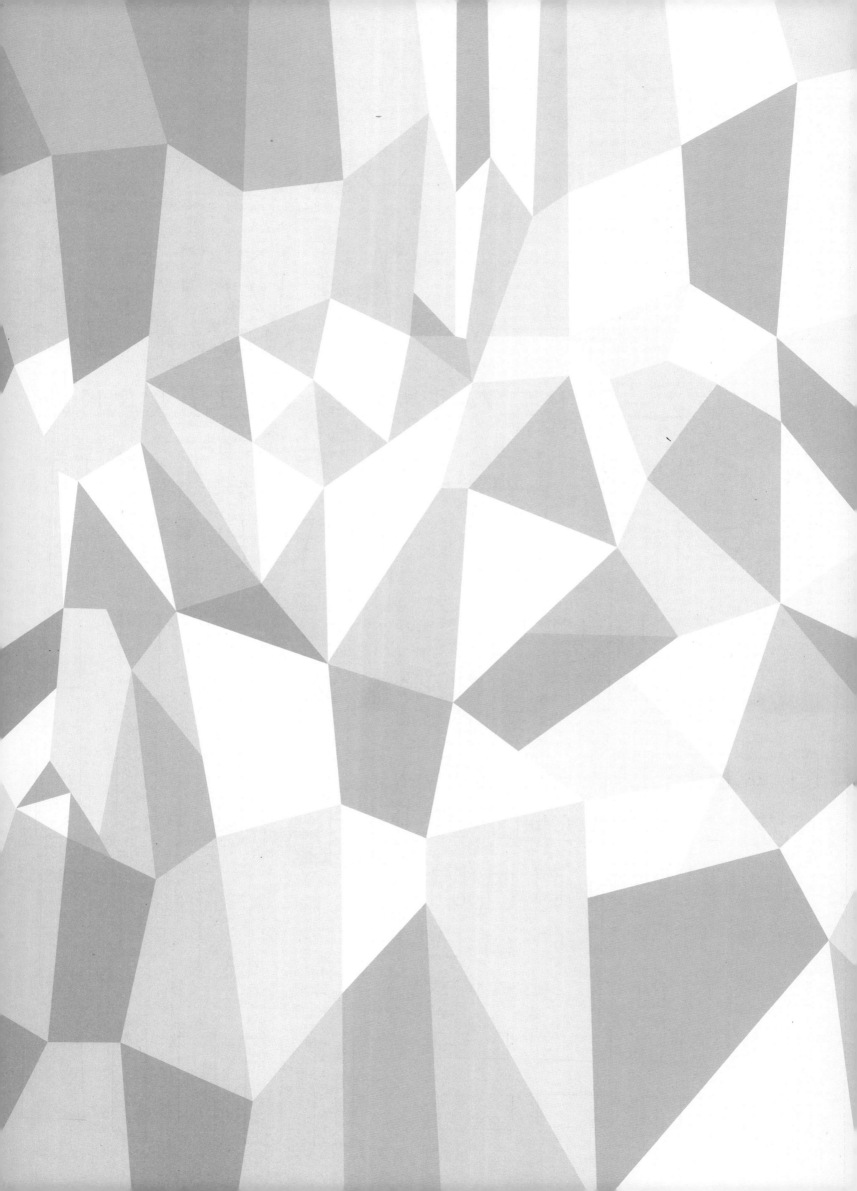